P9-CQZ-757

CAMBRIDGE INTRODUCTION TO THE HISTORY OF ART

The Twentieth Century

Other titles in the series

The Twentieth Century

ROSEMARY LAMBERT

CAMBRIDGE UNIVERSITY PRESS
Cambridge
London New York New Rochelle
Melbourne Sydney

Published by the Press Syndicate of the University of Cambridge
The Pitt Building, Trumpington Street, Cambridge CB2 1RP
32 East 57th Street, New York, NY 10022, USA
296 Beaconsfield Parade, Middle Park, Melbourne 3206, Australia

First published 1981

Printed in Great Britain by Balding & Mansell, London and Wisbech

British Library cataloguing in publication data
Lambert, Rosemary
The twentieth century – (Cambridge introduction to the history of art).
1. Art, Modern – 20th century
I. Title II. Series
709′.04 N6490 80–40456
ISBN 0 521 22715 1 hard covers
ISBN 0 521 29622 6 paperback

Contents

Acknowledgements

The author and publisher wish to thank all those institutions and individuals listed in captions for permission to reproduce illustrations. The following are also gratefully acknowledged:
Reinisches Bildarchiv for p.16; Bildarchiv Preussischer Kulturbesitz for p.17 (below); Berbert Matter for p.37; Studio Vista Ltd for p.52, DIM chairs reproduced from M. Battersby *The Decorative Twenties*, 1969; Artemis Verlag for p.53, Citrohan House from W. Boesiger, *Le Corbusier*, 1972; The Architectural Association for p.56 (top); *The Architectural Review* for p.56 (centre right); Royal Institute of British Architects for p.57 (top); London Transport Executive for p.57 (below); *The Times* for p.80 (left); Robert E. Mates for p.80 (right).

1 The break with tradition

Twentieth-century art is of particular interest to us because this is our time and we are part of it. In the twentieth century more things have changed and changed more quickly than in any previous time, and these changes are reflected in art. The twentieth century is unique for the sheer amount of change and experiment in painting, sculpture and architecture.

The first main break with tradition came as early as 1789, with the French Revolution. Since then artists have felt that the accepted subjects for works of art, such as history, religion and mythology, were not necessarily the part of their lives and experience that they wanted to express in their work. They wanted to paint what they pleased and not just put their own emphasis on what they had been commissioned to do; this attitude was really the beginning of modern art. The artist still took a subject, something that we can recognise quite easily, but he did what he liked with it. He could emphasise a particular aspect by exaggerating it, as Goya did. He could use the colour that we expect to see, or he could use a completely unexpected colour that meant something to him personally, as van Gogh did. He could make scientific experiments in colour, as Seurat did. He could take parts of a landscape or still life as seen by the moving eye, and rearrange them in one composition, as Cézanne did; or break up the subject and put it together again in a different way, as the Cubists did. He could present the image distorted by his own feelings, as the Expressionists did, or almost drop the recognisable subject, as Kandinsky did when he filled spaces with colour and suggestions of objects to express feelings and sensations (see page 3).

All these were possibilities. Of course they were not entirely new ideas and we can see many of these elements in the paintings of the past. But in the twentieth century artists consciously took up and worked out single elements as the main principle of their art.

Often a group of artists worked together in developing one approach. They exhibited their pictures together and talked or

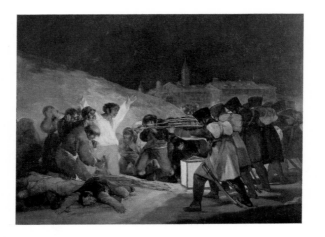

Francisco Goya, *The Third of May 1808*, 1814–15, oil on canvas, 262.5 × 400 cm, Prado, Madrid.
Goya emphasises horror by exaggerating the size of the kneeling victim.

wrote about their theories. Someone found a name for what they were doing, and they became a 'movement'. Sometimes the movements followed one another in quick succession and artists might belong to one and then to another. Though the movements might not always be distinct, their individual character is sufficiently clear to make them our main key to the period. Getting to know them is one of the ways of learning to enjoy the art of the twentieth century.

Of course, not every artist belonged to a movement. There are many fine examples of painting, sculpture and architecture in traditional styles, and some artists took only as much from the movements as they wanted. We have therefore many different kinds of art in the twentieth century. Some of it draws mainly from the past; some of it draws mainly from other new movements. All this can make things difficult for us. If we do not know where the artist's ideas came from, it is hard to know what his painting is about; and why he has chosen that particular technique, when there are so many to choose from. If we look and read carefully we can put a work of art into historical context, and that will tell us more about it. Then we can go on to think about the shapes and the colour, whether they please us, whether we like the painting or sculpture or building, how much we know about what the artist was trying to do, what he was trying to 'say'. We must at least try to go this far. We should not dismiss an artist's work as too mystifying or difficult because it does not give immediate information and pleasure. Twentieth-century art often has to be worked at to be enjoyed.

The art of our time cannot be understood without attempting to look clearly at the changing ideas and the styles of living which have made the twentieth century so completely different from previous

2

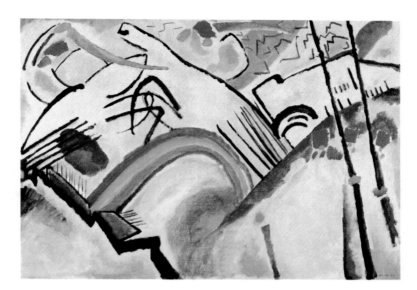

Wassily Kandinsky, *Battle*, 1910, oil on canvas, 94.5 × 130 cm, Tate Gallery, London, Ⓒ ADAGP. Suggestions of weapons evoke the heroic rhetoric of war.

ages. For instance, the increasing rush and movement of everyday life affects both art and philosophy. In the late nineteenth century the first electric train, the Paris Metro, speeded up life in that city. At the same time, Bergson, the French philosopher, was working on theories of time, change and development, of time as a continuous process rather than as a succession of separate instants. In 1902 Freud's first book on the interpretation of dreams appeared, and a French director made one of the first silent science-fiction films, 'A Trip to the Moon'. In 1905 Einstein's theory of relativity developed Newton's theories, again dealing with space, time and motion. The first newspaper photographs appeared and people became visually conscious of what was happening thousands of miles away. 1906 saw the telephone in everyday use. The first flight across the Atlantic was coming soon; so was the first family car, the Model T Ford.

People's sense of time and distance was changing. They were on the move and moving faster. The world around them was changing. It is not surprising if many felt uneasy and confused. Isolation became impossible. The insistence on the present and the future also made the past count for less and less. How was an individual to react? How, especially, was an artist to react? In the chapters that follow we shall look at the way artists in the twentieth century have responded to a rapidly changing world.

3

2 The new movements

CUBISM

Cubism, the first of the new art movements in the twentieth century was a turning-point in the history of art. It was a new way of representing the subject of a painting.

Throughout the ages artists have tried to solve the problem of how to represent the three-dimensional world on the flat surface of a canvas or panel. Since the fifteenth century artists had followed the rules of perspective drawing whereby things in the foreground are larger and things in the distance smaller. This gives an illusion of depth to a picture. Then in the nineteenth century the French artist Paul Cézanne had tried a new way. He studied the natural landscape carefully, identifying the geometrical shapes in houses, trees or mountains but not necessarily seeing them from one point of view.

Paul Cézanne, *La Montagne Sainte-Victoire*, 1886–8, oil on canvas, 66 × 90 cm, Courtauld Institute Galleries, London.

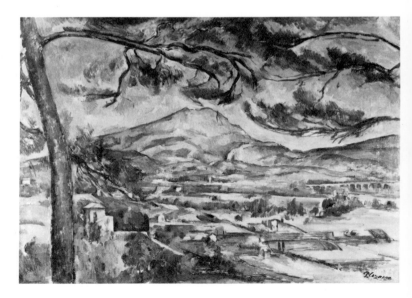

This is perhaps so as to be true to ordinary vision, in which no one's eye keeps still. Then he rearranged these shapes into a composition of the objects he wanted to depict. The eye of the viewer recognises the separate shapes but the total landscape is pieced together in the mind. It is a process which goes on whenever we look at things, but it was a new way to organise a painting. It meant abandoning traditional perspective.

In 1904 a large exhibition of Cézanne's work was held in Paris. It made an enormous impact and it encouraged young painters to try new ideas. At the same time Vincent van Gogh's and Paul Gauguin's work was exhibited, and the simplicity and strength of their work turned artists' attentions right back to the beginnings of art. There was a new interest in African art and in early cave-painting. Of course 'primitive' objects had long been in the museums, and people had looked at them, but as curiosities rather than art. Now artists began to look with admiration at the power and simplicity of primitive ceremonial objects and to seek renewal and inspiration from them.

The artist who painted the first Cubist picture, the Spaniard Pablo Picasso, was one of the first to turn to the prehistoric past. This was consistent with his temperament: his immense output of new ideas drew continually on the work of earlier artists. But, as we shall see, his interest in primitive art was much more than casual. Picasso made people feel, as he must have felt himself, that at this point in Europe's history, the very crudity and savagery of African art suddenly had value. Picasso began as a traditional painter, with a normal training in drawing, giving him a skill of hand which gave him command over the subject even when he had abandoned traditional drawing altogether. His experimental painting can be divided into several periods. In his 'Blue' period he used colour to express harshness and poverty. In the 'Rose' period his figures became more rounded and sculptural, though his subjects, clowns and columbines, still create a sense of melancholy. Then, in 1907, he produced a painting that shocked those who saw it. His famous *Demoiselles d'Avignon*, a brothel scene, became the prototype Cubist painting. The figures seem to be composed of various facets of the female body but seen from different angles, showing what we know to be there rather than what we see at a glance. The distorted figures have

Pablo Picasso, *Les Demoiselles d' Avignon*, 1907, oil on canvas, 244 × 234 cm, Collection, The Museum of Modern Art, New York, acquired through the Lillie P. Bliss Bequest, © SPADEM.

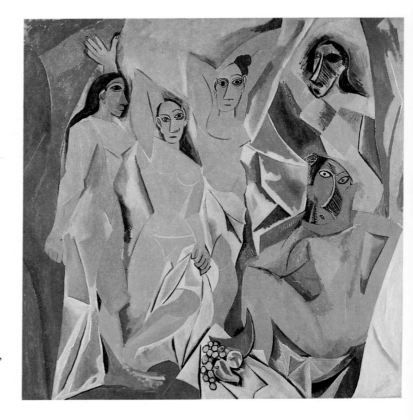

below

Ashanti mask, West Africa, nineteenth century, wood, height 36.5 cm, University Museum of Archaeology and Anthropology, Cambridge.

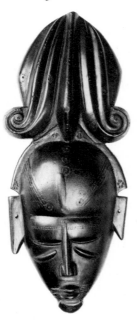

been almost entirely flattened; there is little space behind or in front of them so that they are thrust forward, and leave no polite distance between us and them. We can see how determined Picasso was to keep everything at the picture surface if we look at the blue background to the right. This colour would normally recede, but by outlining it with white Picasso has brought it sharply forward. The figure on the left has the stance of ancient Egyptian figures; the next two recall figures in early Iberian art; and the two on the right have the grimaces of African masks. Picasso used exotic art because it provided a precedent which made it easier to move away from traditional methods of representing a subject. He fragmented the figures and brutally rearranged some of the faces to achieve a savage effect, which he knew would shock. The way the painting is arranged, its composition, is almost a caricature of Cézanne's way of organising a painting.

When Georges Braque first saw Picasso's *Demoiselles d' Avignon*

6

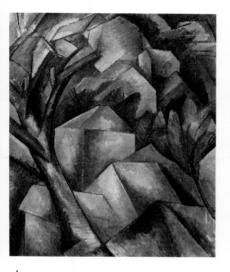

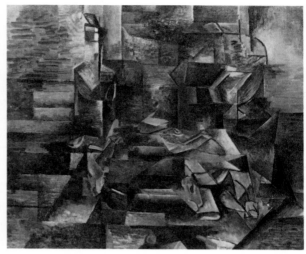

he was astonished. Braque had become discontented with his own experiments but now he painted *Houses at l'Estaque*. This picture too is a response to Cézanne's ideas. Braque abandoned perspective and built up shapes with colour. He lit each shape separately rather than depicting a landscape where light comes from one point. Even the diagonal of the tree is a device that Cézanne used.

So Braque and Picasso had something in common; they were both replacing traditional perspective, and its illusion of three dimensions, with a much shallower pictorial space. They showed figures and objects as if they had been pushed forward to the surface of the canvas. They also showed them as collections of solid shapes arranged to make a new composition. Picasso painted in his direct, sometimes brash way; Braque in his more sensitive manner. The critics said that they were producing laboratory experiments, not works of art.

In what is now seen as the first phase of Cubism, from 1907 to 1909, Picasso and Braque still worked very much under Cézanne's influence. But gradually they developed a style more distinctly their own. They painted landscapes which at first glance looked as if they might be still lifes. The whole illusion of depth was taken away and the elements of the scene were brought forward, lifted out of context, even piled up like objects in a box. This was the transitional stage of Cubism. Any interest we might have in the subject seems to be discouraged; we are fascinated by the artist's skill in making it almost disappear.

In the next phase of Cubism, now known as Analytical Cubism,

7

from 1909 to 1911, the subject became still less important than the way in which it was treated. Braque and Picasso seem to have decided that their approach could be better defined and developed by choosing a subject in an enclosed space, such as a still life, where the surroundings did not interfere. Neither did they want the distraction of colour, so they introduced a severe palette of blacks, greys, browns, and ochres. Taking the subject, then, they conceived the idea of viewing it from all sides, and then giving all these facets simultaneously in one view. In theory this was to show as much of the subject as possible. In practice, it made recognition of their still-life objects very difficult.

The herrings and the bottle in Braque's *Still Life with Herrings* have to be put together from the visual clues that we are given. From the title we know that we are looking at a group of objects, but the way in which these objects are broken up makes us much more conscious of the space they occupy, and the claustrophobic way they fill it, than of the objects themselves. Because the objects seem almost to fill the painting they have a monumental quality. We sense the artist's intense concentration on a few domestic things, a concentration that makes the objects seem to extend into the air around them.

How far it was right to go in disintegrating the subject was obviously a matter of fine judgement. The idea was to go as far as possible without losing it altogether. They could not actually abandon the subject, or the whole point of taking apart these bottles, guitars, wineglasses, and even people, and reassembling them, would have been lost.

Having gone so far, there was nothing now for Picasso and Braque to do except to put recognisable things back. But this is not a return of the whole subject, merely of 'things', whose sole purpose is that they are recognisable. In the third phase of Cubism, called Synthetic or Collage Cubism (1911–16), we find letters, whole words, numbers, and the occasional real object introduced into pictures. Another idea, conceived by Braque (a former house painter), was to paint imitation wood grain. This is an ingenious play on the question of 'what is real?' Instead of making an illusion of wood by painting 'fake' real wood (as in conventional painting), he has introduced traditional housepainters' woodgraining, in other

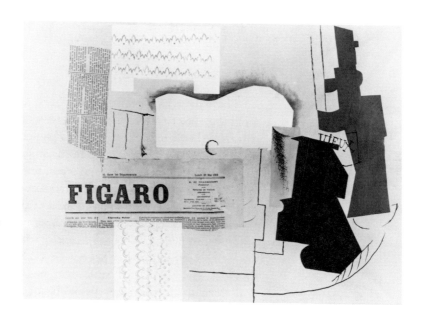

Pablo Picasso, *Bottle of Vieux Marc, Glass, Guitar and Newspaper*, 1912, mixed media, 44.4 × 61.3 cm, Tate Gallery, London, ©️ SPADEM.

words, real fake wood. All sorts of humorous devices were used to make it possible to forget the painting for the subject, including real sawdust, cut paper, and even tobacco stuck to the surface of the painting.

Why did the Cubist painters react so strongly against the idea of painting as an illusion? We do not know. One reason might be that the artist was asserting himself, refusing to be a mere channel from subject to spectator. Perhaps he could not honestly be a channel any more, because he no longer felt sure that he knew what reality was, that what we see as ordinary bottles, guitars, tables, is the whole story. But that leads us to an unsolved question. Do these paintings show an uncertainty about the reality we know, or a certainty about some other reality? Some writers are prepared to believe the latter, that Cubist painting is intended to give a deeper insight into objects than do paintings which merely show what things look like. It is not a question of how much of the object you show: pictures are still two dimensional, and all leave much to the imagination. Cubist paintings may show various sides of things, but the mind still has to complete the picture from what we know. In fact, the evidence of our eyes is that Cubist paintings give us a great deal less information about objects than conventional paintings do. Who could ever guess from the Cubist paintings what a glass and a guitar looked like if he had never seen them? So the question is whether 'less' can ever be 'more'.

9

There have long been philosophers, and some artists, who have held the view that less of appearance can mean more of real truth, who have thought that behind what we see there is something else. It is a view that, as we shall see, Mondrian held (page 31). But painting is a visual medium, and even if a painter thinks he knows what lies behind what we see, he has to convince us visually. No philosophy could convince us that what he shows us in a particular painting is true, unless we can also see it for ourselves. We still have to decide whether we have gained anything, apart from the fun of a puzzle, from this destruction of appearances. We may have to conclude that, after all, less *is* less, that 'more real' has only turned out to be less real. Perhaps abandoning representation has, after all, meant losing the subject. But then this might have been what the Cubists wanted, because, as we have suggested, they were more interested in asserting the presence of the artist, than saying anything about the reality outside him.

Other painters and sculptors used the ideas of Picasso and Braque in their own ways and took them into their own movements. Juan Gris, another Spanish painter, had come into contact with the Picasso circle in 1906. He developed Cubism even more strictly and intellectually than Picasso and Braque, organising the structure of the painting before he let the objects in it become recognisable as, for instance, mandolins or fruit. The French artist Robert Delaunay had been painting scenes and objects with pure colours in small dots, a technique called Divisionism. He continued to be more interested in colour and light than in the 'analysis' of the subject and came even nearer to losing the subject of the painting than Picasso and Braque had done. His style was called Orphic Cubism, a movement that was going on from 1910 to 1914. Another painter, Fernand Léger, simplified his forms into geometric shapes much more than Cézanne had done, but rearranged them against a background that had depth, and used bright colours to suggest that depth. Later he painted workers and machines, the people being subordinated to the machines. Léger's painting is a combination of Cubism and Realism.

The new style called Cubism was therefore a particular treatment of the subject, a way of breaking it up, analysing it, relating one part to another in different ways, simplifying the subject to relate it more

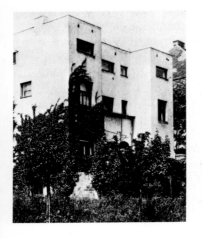

Adolf Loos, Steiner House, Vienna, 1910, Loos Archiv, Graphischesammlung, Albertina, Vienna. Cubist influence in architecture.

intensely to the space around it; in short, abolishing the painting of a subject as an illusion. Though the precise purpose of this experiment is still unclear, the historical consequences of Picasso's and Braque's work were momentous. In a short span of years they had broken almost all the taboos and traditions of Western art, so giving to all artists the freedom, and the insecurity, of painting without rules.

FAUVISM

The Fauves were a small group of painters who worked in Paris at the beginning of the century. The name, which means wild beasts, was given to them when they exhibited in the Salon of 1905. The leader of the group was Henri Matisse, and the other members, who included Derain, Vlaminck, Dufy, and Braque, came from several different groups. What they all had in common was their interest in pure, brilliant colour. Matisse started by copying colour prints when he was convalescing from an illness; then he became a full-

below
Henri Matisse, *Portrait of Madame Matisse with a Green Streak*, 1905, oil on canvas, 40 × 32 cm, Statens Museum for Kunst, Copenhagen, © SPADEM.

below right
Henri Matisse, *The Snail*, 1953, gouache on cut-and-pasted paper, 286.4 × 287 cm, Tate Gallery, London, © SPADEM.

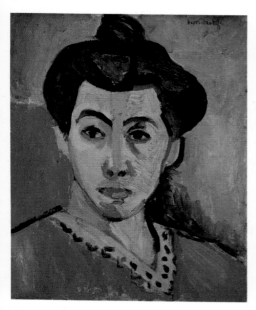

time painting student. His early work was very competent and was influenced by Cézanne whom he admired greatly.

When Matisse failed the entrance examination into the School of Fine Arts, Gustave Moreau, a particularly imaginative teacher and painter, took him into his studio. Here the young Matisse studied the compositions of Raphael, the Dutch masters and Poussin, as well as Moreau's flowing linear decoration based on the 'arabesque', the curving intermingled lines of foliage in Islamic art. Matisse became a master of the curved line; we can follow it in the firm sensitive drawings he made right through to the 1950s. Most of all, though, he loved colour and used it to give pleasure, not just to describe things.

Matisse experimented with several styles but, by 1905, influenced by the clear light and bright colour of the landscape in the south of France, he had found his own style. It seems astonishing now that this Fauve painting was considered wild. The colour was brilliant but the composition was highly organised. Matisse used intense colour because that had the most impact even though the colour was not always 'correct'. If he thought that he could make his point better with a different colour, he did so. He used colour rather than light and shade to suggest space, to indicate light, and often just for decoration. This full use of colour is very well illustrated in the portrait of *Madame Matisse with a Green Streak*. The portrait is very intense and at the same time calm, which would seem to be a contradiction. The position of the head and shoulders in the painting is quite conventional but the modelling, the shaping of the features, is not. Why has he painted a green streak down the centre of the face? If we look at it with half-closed eyes and try to cut out the green streak the portrait seems incomplete. It seems as if all the modelling of the face, the hollows and highlights of skin over bone, has been condensed into that green stripe down the middle which balances the two halves of the face and the strong eyes. The dark eyes and eyebrows would be overpowering without it. It joins the dark hair to the green collar and 'holds' the face in relationship to the hair and the dress. It connects the face to the background, the vivid green and red of the background patchwork, which are repeated in the dress. The opposition of these two colours sets up a dazzling vibrancy which does not allow for depth; everything is on the surface. There is so

much happening in this painting of a passive subject, and the effect is achieved by the calculated use of colour. This is not so much a result of colour theories like Seurat's or those of the Impressionists, as a personal affirmation of the vivacious, life-enhancing qualities of colour. And it makes an unforgettable portrait.

By about 1908 Fauvism had reached its greatest intensity. The movement had been taken to the limit by young artists who still had a lifetime of work ahead of them. Matisse was aware of course of what the Cubists were doing – his own collection of primitive art had been a factor in their interest in early art – but their analytical exploration did not suit his temperament and he continued in his own way. He was strongly impressed by the Islamic exhibition in Munich in 1910, and subsequently travelled to Tangier. The combination of colour and order in Oriental art had great appeal for him and he was again exhilarated by the strong bright light of northern Africa, as he had been earlier in the south of France.

Later, in the 1950s (when his hands were too arthritic to paint), he made the cut-outs which were a culmination of his earlier simplifying and intensifying, to suggest the essential qualities of a subject. His paper cutting was like the direct carving of a sculptor. He mixed the colours then 'drew' on the coloured paper using the scissors like a pencil. The effect was strong and immediate despite the simple means. *The Snail* is one of these cut-outs. The movement starts in the centre and spirals out. The pace of the movement seems now quick, now slower. The jagged border is part of the spiral but also holds it in. And Matisse is again manipulating colour. Yellow should usually seem to come forward and green recede but here they overlap and disobey the rules.

EXPRESSIONISM

Edvard Munch in his painting *The Scream* expresses total despair; everything in the painting reinforces despair. The human figure has no substance, it bends and waves under the pressure of its emotions. The sinuous shapes of sky and water and the strong diagonal of the bridge all lead the eye to the mouth that is opened in a scream. Although there are other people on the bridge, there is an atmos-

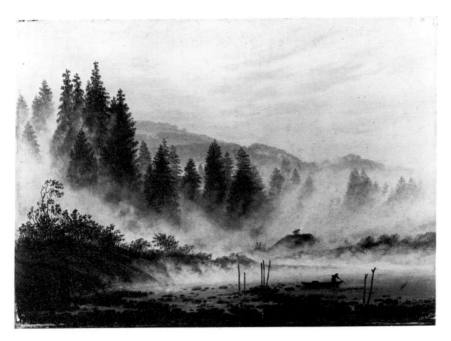

Caspar David Friedrich, *Morning*, 1820, oil on canvas, 22 × 30.7 cm, Niedersächsise Landesmuseum, Hanover, Landesgalerie.

phere of terrifying isolation. The cry is that there is no escape from *being*, only the unbearable pain of it. In the picture there is no relief for the eye, no part of the background that is not agitated. The emphasis on strong lines and strong rhythms, and the agitation in the handling of the paint all make visible the artist's emotion. Munch, a Norwegian, was obsessed with death and shows a condition that seems worse than death.

Expressionism is the name given in twentieth-century art to paintings like this in which states of mind have become the subject of the picture and are depicted so forcefully that the ordinary appearance of things is distorted. The disadvantage of Expressionism, however, lay in the fact that many extreme states of mind are too personal to the artist to have much meaning or interest for anyone else. But in their greatest pictures, such as *The Scream*, the Expressionists uncovered a broad human desperation which had previously had no pictorial expression. Worringer, the German art historian, suggests that Expressionism is not just a style but a strong recurring tendency, found mostly in northern Europe as if the cold northern world induces feelings of insecurity and fear. It helps to explain the modern Expressionist movements if we trace this tradition back.

For the best part of two hundred years after the 1520s, painters in

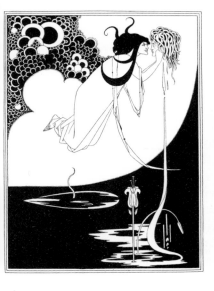

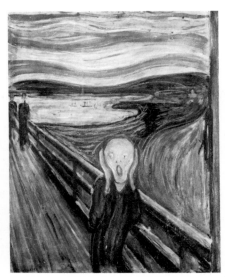

that large area of central Europe, which is now Germany and
Austria tended to copy artistic trends in Italy and the Netherlands.
But though German painters travelled and took up various ideas
they worked them out in a poetic and often exaggerated way. In the
eighteenth century, when the unification of Germany, so long hoped
for, did not come about and patriotism was stifled, artists turned
away from the frustrations of the world of politics to the inner world
of the imagination. In their romantic world, former times seemed to
be happier times.

Caspar David Friedrich was working at the same time as
Constable, Turner and Blake in England. He painted carefully
observed fragments of nature, consciously chosen and put together
to create a certain mood rather than to record a particular place and
time. He used traditional symbols, the evergreens of eternity, the
rocks of faith, mist as the enigma of death. Even though Friedrich's
subjects employed familiar elements they were melancholy and
uneasy.

There was something of the same tendency in the movement
known as Art Nouveau which swept across Europe towards the end
of the nineteenth century and became international. This can be
seen in the tortuous lines of the English artist Aubrey Beardsley. In
Germany the movement was called Jugendstil, or Youth Style, the
name of a periodical, and the artists there produced even more tense
and sinister pictures with a strong emphasis on twisting lines.

At the same time other groups of artists in Germany and Austria

were trying to introduce Impressionism and have it acknowledged. Various 'secessions' took place, as artists withdrew from their art establishments and set up their own groups. By 1903 there were on exhibition in Berlin pictures by Munch, Cézanne, van Gogh and Gauguin. It is not surprising that the painters who showed most emotion, Munch and van Gogh, had the greatest influence.

In 1905, a new movement was formed in Dresden. It was called Die Brücke, the bridge, because its founders wanted to link the past with the future. The movement was started by four architecture students, Ernst Ludwig Kirchner, Erich Heckel, Fritz Bleyl and Karl Schmidt-Rottluff, who turned to painting, lithography and woodcuts because they could express their feelings more fully in these materials.

The Brücke artists had a frenzied dedication to what they were doing. They worked with a sense of urgent creativity, of hurry to get the picture down. They used the subject of the picture to express their own intense feelings, and they did not hesitate to distort it to achieve the effect they wanted. In this they were like the Fauve artists, but they did not acknowledge any influence. Their pictures also resemble Cubist work in that there is very little perspective or background.

Ernst Kirchner, cover design for *Die Brüke*, 1909, woodcut, Neuerburg Collection, Wallraf-Richartz-Museum and Museum Ludwig, Cologne.

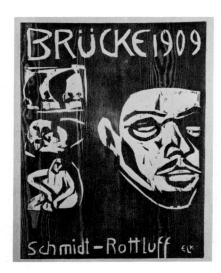

Erich Mendelsohn,
Einstein Tower, Potsdam,
1919.

After the First World War
there was an 'Expressionist'
influence on architecture
before buildings became
plain and functional in the
new modern style.

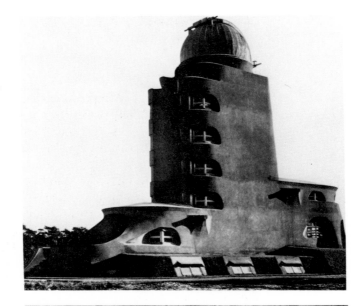

Ludwig Mies van der
Rohe, Friedrichstrasse
office building, Berlin
(project), 1919, perspective
drawing, charcoal and
pencil on brown paper
mounted to board,
170.6 × 120 cm, Collection,
The Museum of Modern
Art, New York, gift of
Ludwig Mies van der
Rohe.

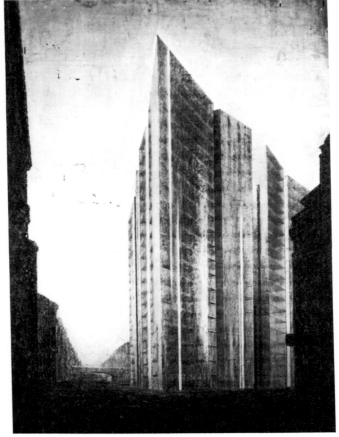

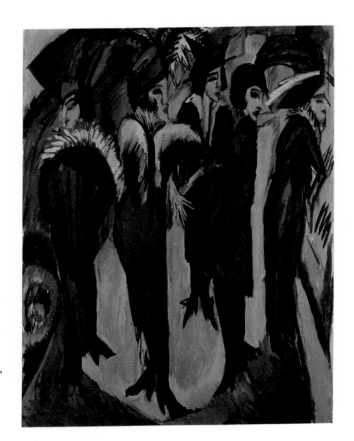

Ernst Kirchner, *Five Women in The Street*, 1913, oil on canvas, 118.7 × 89.7 cm, Wallraf-Richartz-Museum, Cologne.

The Expressionist view, the atmosphere they sensed and emphasised, is very well shown in Kirchner's *Five Women in the Street*. Women in the street can be shown in any number of ways. These women are fashionably and expensively dressed, standing by a shop window to look at further luxuries. Not a sinister subject, and yet the whole atmosphere of the painting is sinister. The women seem frozen in their spiky poses. The activity is all in the harsh dry paintwork. Perhaps these are expensive prostitutes; or has the painter made wealthy wives look like expensive prostitutes? Their extremities, the shoes and the hat decorations, are pulled out so that they look spiky and vicious, and this effect is echoed in the faces with their vermilion lips and hard expressions. Dark clothes and hats against pale faces can give an effect of fragility. Here they emphasise the harshness, the dislocation. The green shadows of the background reflect on to the flesh tones; everything conveys an atmosphere of decadence. The subject crowds the canvas; there is no rest for the eye.

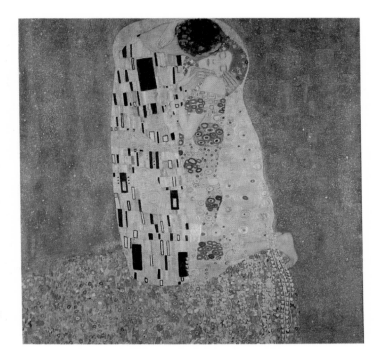

Gustav Klimt, *The Kiss*, 1907, oil on canvas, 180 × 180 cm, Österreichische Galerie, Vienna, © by Galerie Welz, Salzburg. The decoration reminds us of Botticelli but the lovers' pose is uneasy.

THE VIENNA SECESSION

In 1898 another secession from established art took place in Vienna. It was led by Gustav Klimt. He had been a student at the technical college under a distinguished teacher, Laufberger, considered very modern at the time. Klimt did not have to wait long for some important commissions: a theatre curtain for Karlsbad, prize-winning painted ceilings for the Burgtheatre and plaques for the staircase of the Art History Museum in 1890. In 1897, while he was a member of the Kunstlerhaus, a conservative art society, Klimt did some critical thinking about his own work and that of others. This led him to form his own group and then to found the Vienna Secession and its monthly magazine *Ver Sacrum*. The aim of the Secession was to achieve the interaction of art with life, to produce art that would mean something to everybody and that would not rely on old and copied ideas. Nevertheless the Secession had some very severe critics among intellectuals and artists who thought that the time had come for absolute truthfulness in art. For them Klimt's painting with its Art Nouveau shapes and dazzling decoration was simply a façade for the privileged that concealed the reality of the declining Hapsburg empire. The literary critic, Karl Kraus and

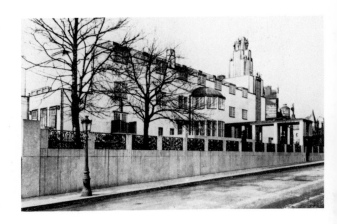

the architect, Adolf Loos (page 10) called ornament a crime and
denounced it passionately. Perhaps they could have had no better
target than the luxurious and costly Maison Stoclet for their
accusation that the Secession was not living up to its aim that art
should be for all.

In 1903, Koloman Moser, a Secession painter, and Josef
Hoffmann, an architect and designer, founded an arts and crafts
workshop, the Wiener Werkstätte. The workshop was based on
ideals of simplicity and unity of style which had been developed by
William Morris and the Arts and Crafts movement in England. The
idea behind the Wiener Werkstätte was that all the crafts, including
furniture, table silver and linen, should be judged by the same
standards as painting and sculpture. Moser also designed the loose
flowing dresses which were sometimes worn, with Hoffmann's
jewellery designs, by Alma Mahler, the composer's wife – these
were Gustav Mahler's years as conductor at the Vienna Opera
House.

The idea that painting should show the truth was taken to the
limit in a very personal way by Egon Schiele, a turbulent young
man with a fine talent for drawing, who admired Klimt and received
encouragement from him. Schiele's working life was short; he was a
student from 1906 and died in 1918. His work, understandably,
caused revulsion in his time. He revealed himself deeply in his
drawing and painting, and seemed genuinely bewildered when he
was accused of indecency. He felt that he had something valuable
and truthful to give.

Vienna was full of contradictions: the rigid formality of the court
hid a dying empire; the repressive morality brought a reaction
which provided the themes of Schnitzler's plays at the turn of the

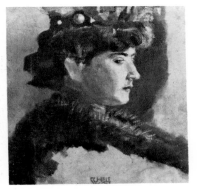

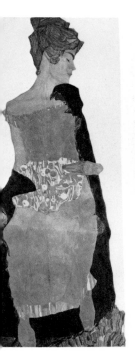

century. The teaching of Freud, uncovering so much of the human psyche that had been hidden, was part of the intellectual climate, though Freud himself was very divided about his own discoveries and was not a happy rebel.

Schiele's painting showed his fears, his fantasies and a brutal self-punishment. His relationship with himself and others, particularly with his sister Gerti was intense: in one painting he illustrated her adolescent sensations and guilts as breaking out visibly on the skin. His figures were often placed in a void, sometimes outlined, and with their length exaggerated. His street children, playing, seem paralysed with anxiety in contrast to the crumpling of their clothes and the agitation of their hands. In spite of the emphasis on anxiety, the children and Gerti are treated with a great deal of sympathy for their adolescent awkwardness. Before he died, in the influenza epidemic of 1918, Schiele had held a successful exhibition at the Secession building and had won recognition.

FUTURISM

The Futurist painters, led by the poet Filippo Marinetti, were working in Italy from 1909 to 1916, roughly during the same time as the Cubists in France. This group, amongst them Umberto Boccioni, Gino Severini and Giacomo Balla, thought that Italy was imprisoned by her past glories and had to be made to step into the future. Their wider aim was to bring European culture into what they saw as the glorious new world of modern technology.

The Futurists tried hard to deny the past. They were very keen on publicity and their first manifesto, written by Marinetti in 1909, was in praise of youth, machines, movement, power and speed. The

Giacomo Balla, *Abstract Speed – The Car has passed*, 1913, oil on canvas, 50.2 × 65.4 cm, Tate Gallery, London, © SPADEM.

second, a year later, attacked classical techniques in painting and what they termed the superficial modernism of Secession art. The idea of the future as something exciting and glorious was very strong at this time. The painting of Picasso, the music of Igor Stravinsky, modern technology, all seemed to be leading into an exciting new era. (Now, in the late twentieth century, changes come so quickly that we have ceased to think of the future in those terms.) The key word of this new movement was dynamism, a universal force, and this is what had to be shown in painting. The Futurists used dynamism to glorify violence; their manifesto proposed burning the museums, the guardians of the past, and they saw war as something fast, noisy and theatrical. This attempt to come to terms with the machine by glorifying it was futile as became evident in the First World War when the machine gun was the cause of undreamt of horror. The real contribution of the Futurists now seems to be their 'simultaneity', a way of putting together visually in a painting things that happen together in time: sound, light and movement.

Futurism was a movement that embraced all the Arts. For instance, Luigi Russolo, painter and musician, painted a chord

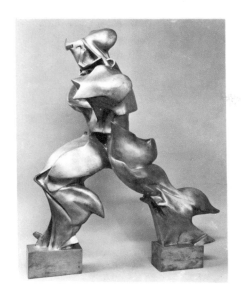

Umberto Boccioni, *Unique Forms of Continuity in Space*, 1913, bronze (cast 1931), height 111.4 cm, Collection, The Museum of Modern Art, New York, acquired through the Lillie P. Bliss Bequest, © SPADEM.

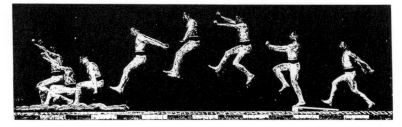

Etienne-Jules Marey, *Successive phases of a Long-jump*, chronophotograph, from E. J. Marey, *Movement*, New York, 1895.

rising from a piano and becoming a pattern and he developed sound-producing machines as part of musical 'happenings'.

The critics of the Futurists, many of them Cubist supporters, accused them of being photographic, and compared their work to multi-exposure high-speed photographs. Of course, the Futurists knew the work of Muybridge, the English photographer who worked in America, and Marey, the French physiologist, but they denied the influence. Even so we cannot entirely disregard the influence of photography when we look at the Futurists.

Boccioni's sculpture, *Unique Forms of Continuity in Space*, shows very forcefully the dynamism of the human figure. It seems to embody movement in three-dimensional form, and light and even sound. Boccioni spoke about the necessity of breaking the rigid contours of the figure, of creating a dynamic continuity in space, and of fusing the figure in its environment. The chronophotograph is *Successive phases of a Long-jump* by Marey; it is hard to believe that these two are no more than parallel developments.

23

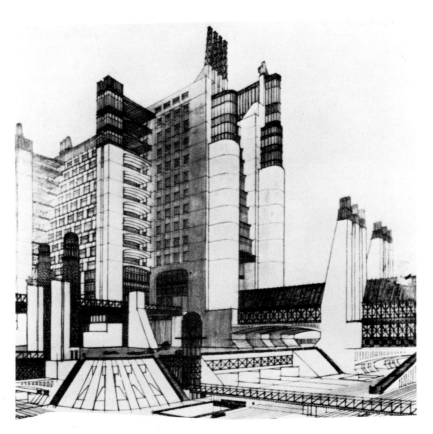

Antonio Sant' Elia, *La Città Nuova*, perspective, 1914, pen and ink, Museo Civico, Como.
Do Futurists' depictions of movement work best in painting, sculpture or architecture?

Could there be Futurist architecture? There was argument, even at the time, as to whether the architect Antonio Sant' Elia was a Futurist. His vision of cities with circulation on many levels, with railway and road tunnels topped by landing spaces for aircraft, certainly looked prophetically towards the needs of cities in the second half of the century. Sant' Elia may well have known what the Viennese architect Loos (page 10) was doing. His buildings are equally without ornament, but Sant' Elia goes further and allows the function to show as part of the design. Lifts are put on the outside of the building because they look well in movement; they express something the architect wants to emphasise. The new city in this picture remained an idea; it was never built.

Boccioni and Sant' Elia were killed serving in the First World War. Not surprisingly, the movement could not survive the actual realisation of its ideals of violence and mechanisation, and soon disintegrated.

Balla's painting *Abstract Speed – The Car has passed* sums up, even

62016

in its title, the Futurist idea of what painting should be. He said 'when the speeding object moves, everything else moves. The car rushes through and passes into everything else; it shatters the atoms of light and leaves a shudder.'

Another painting which emphasises a dynamic pattern of movement, this time human movement, is the English artist David Bomberg's *Mud Bath*. Bomberg was a member of the Vorticist group, the English equivalent of Futurism. The movement was started around 1912 by the painter Wyndham Lewis and the poet Ezra Pound. The Vorticists' work was more abstract than the Futurists' and closer to Cubism. Bomberg had worked with artists from both movements and *Mud Bath* shows how he combined the techniques (page 26).

The idea of painting a group of moving figures came to Bomberg after a visit to a public bath house in the East End of London. The figures are flattened and simplified almost to abstract shapes, yet they animate the whole surface of the painting. The angular shapes and the strong colour increase the sense of movement, while the cut-off rectangle of red, and the vertical black pole, define the space and seem to restrain the almost wild movement of the figures.

Bomberg is depicting movement by using shapes and colour, and at the same time controlling the movement in the shallow picture space by those same shapes and colour. He is completely confident in what he is doing, and he can combine several techniques in one painting because he understands them so well.

By 1910, the ideas of the modern movements had spread across Europe. The overlapping of movements and ideas was greater now because travel and communication were quicker. The Cubists in Paris knew what the Futurists were doing in Milan. Marcel Duchamp, who worked in Paris in the Fauve manner, was influenced by Cubism and painted a figure descending a staircase in which the treatment of the figure is Cubist, the sense of movement is Futurist and the whole looks like a multiple photographic exposure (page 26).

This picture caused enormous outrage when it was exhibited in New York in 1913. This was because people had not grown used to these revolutionary paintings, or the ideas behind them, but still saw

David Bomberg, *The Mud Bath*, 1914, oil on canvas, 152.4 × 224.2 cm, Tate Gallery, London.

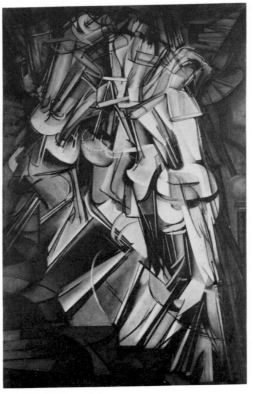

Marcel Duchamp, *Nude Descending a Staircase no. 3*, 1912, watercolour, crayon and pastel over photographic base, 147 × 90 cm, Philadelphia Museum of Art, Louise and Walter Arensberg Collection, © ADAGP.

and responded to the subject on its simplest level. They had become used to seeing guitars and bowls of fruit 'distorted' but it was insulting to see a human figure treated as a machine for movement. It disturbed their ideas both of painting and of people.

3 Moving towards abstraction

THE RUSSIANS

Towards the end of the nineteenth century, the German Art Nouveau painter, August Endell, had said that a totally new art was about to develop, an art with shapes that meant nothing, represented nothing and recalled nothing, but which would have the same emotional effect as music. Music, which comes from the mind of the composer, and only becomes 'real' when it is played, creates a mood or an atmosphere or even suggests shapes and colours in our minds. When it is brought to our ears by instruments it is complete. Why then should not the shapes and colours in the artist's mind, which may not represent any recognisable object, also be complete when they are painted on a canvas? From this train of thought we can see that abstraction in art was on the way. The artist who is generally credited with 'inventing' abstract painting is Wassily Kandinsky.

Kandinsky, who was born in Russia and had studied music, wrote about his feelings when he saw the Impressionist exhibition in Moscow in 1895. There he realised, for the first time, that a painting could be an expression of feeling even though there was no recognisable subject. When he came to Munich in 1896 he found that other artists were thinking along the same lines. Germany was unsettled and philosophers like Nietzsche were saying that spirituality was dead. In this climate, various societies and orders concerned with mysticism, like the Theosophists and the Rosicrucians, had sprung up in an attempt to fill the spiritual gap. There was a renewed interest in Oriental religions, meditation, fasting, anything that might encourage the spiritual nature of man. There was also talk about abstraction in art, about the possibility of colour and shapes from the painter's imagination expressing his ideas completely, without a recognisable subject. Abstraction in art could be seen as a withdrawal from the harshness of reality.

Kandinsky painted for a time in the Bavarian countryside and we have the story that he came in one day after working on an outdoor sketch and saw a painting standing against the studio wall – a painting with shapes and colour, but with no recognisable subject. He then realised that it was one of his own works leaning against the wall on its side, so that it 'read' in quite a different way!

In 1910 Kandinsky joined with some of the painters of Die Brücke to form a new movement called Der Blaue Reiter, or the Blue Rider. This second German Expressionist movement soon became international because by 1910 new art movements were already spreading rapidly in Europe.

The Blaue Reiter artists were in touch with the Cubists and the Futurists and they knew what was going on in other parts of Europe. They had their own publication, *Der Blaue Reiter*, and received further support in Hewarth Walden's magazine *Der Sturm*. Kandinsky, Marc and Klee wrote extensively on how they came to their way of painting. Arnold Schoenberg, the composer, was also one of the group. He was painting in the Expressionist style as well as composing music. His new atonal music was causing as much interest, and hostility, as the new art movements.

In 1910 Kandinsky painted *Battle* (page 3). There are still some recognisable shapes, lines of lances, mountains, a fortress and a rainbow, but these have been simplified and subordinated to the composition. We are conscious, not of the identity of the objects, but of a series of planes made by diagonal lines. The planes are shallow and they contain a variety of shapes and colours ranging from sharp black lines to smudgy paintwork in soft colours. It is perhaps the variety of colour and shapes and the dispersal of them that connects the painting in our minds with music. The suggestions of lances, rainbow and mountains remind us of heroic legend in which there was renewed interest at this time, but narrative has been dissolved into a mood; the atmosphere is stronger than the legend. Kandinsky was reluctant to lose the subject of the painting as he might be left with only decoration. Although *Battle* is decorative, the composition is very formally structured and the atmosphere of the painting comes to us as strongly as it would from a still life or a landscape. It is, in fact, a 'landscape' of sensations.

When Kandinsky went back to Russia in 1914 he found that the

Mikhail Larionov, *Nocturne*, c. 1913–14, oil on canvas, 50.2 × 61 cm, Tate Gallery, London.

Russian painters Mikhail Larionov and Natalia Goncharova had been painting abstract pictures since 1911. Their movement was called Rayonism. While Kandinsky's abstract painting had come, even if indirectly, from Expressionism, the Rayonists drew from different sources. They knew Cubism but had been influenced mainly by Futurism. Futurism had kept a recognisable subject in a painting, and used it as a focus for movement. Now Larionov moved away from any representation of a subject. Instead he became interested in the relationships set up by parallel and converging beams of colour.

The Rayonists' abstraction led to yet another kind of abstraction, the Suprematist movement, started in 1913 by Kasimir Malevich, Vladimir Tatlin, Antoine Pevsner and Naum Gabo. Suprematism, for them, meant painting that allowed an awareness of shapes and colour but did not call up any further associations or feelings. They were aiming, in a mystical way, to express 'pure' states of consciousness, or unconsciousness, undisturbed by actual thoughts. They chose geometric shapes as being the most simple. As the idea developed, even colour had to be dropped because it aroused emotion. They were basing their art on their theory of the human mind and soul – a theory which could be right or wrong. Malevich came to a white square on white paper – which was as far as he could go! Perhaps it is not possible to look at anything, even a white square on white ground, and not make associations or feel something about it. It is interesting to lay one square of white paper on another and see what it suggests to different people.

Tatlin, who had studied under Larionov, visited Paris in 1912 where Collage Cubism gave him the idea of constructing models in relief and then going on to constructions of glass, metal and wood. By 1913 these were completely abstract and were to be the basis of yet another movement, Constructivism. Pevsner and Gabo were both in Paris in 1912 and 1913 doing sculpture and when they returned to Russia in 1917, Suprematism was still strong. Gabo and Pevsner formed the Constructivist movement with Tatlin who coined the name. Their medium was steel; they made their sculptures out of separate pieces, so making them 'constructions' rather than traditional sculptures. The Constructivists thought that artists must constantly try to discover and use new forms because life itself

is constantly changing and renewing. They felt that what was important was not so much the thing they made as the spaces it enclosed.

We have now come in a short space of time from a movement that eventually rejected the subject in favour of feeling, Expressionism, to a movement that rejected distinct feeling in favour of a hoped-for awareness of mystic states, Suprematism, but overlapping a movement that was a visual exploration of shapes and voids, Constructivism.

In 1920, Gabo and Pevsner produced a Realist manifesto to announce that their works were real objects, neither representations nor useful for any functional or political purpose. After a big exhibition in 1922, showing Suprematist, Contructivist, and representational (with a political message) art, the Russian artists went their separate ways. Tatlin placed his art at the service of the Russian Revolution; Gabo and Pevsner refused to do so and left the country. Gabo went to Germany where he later joined the Bauhaus (page 35). Pevsner settled in Paris. In 1931, they were to become founder-members of Abstract Creation, an international movement of abstract artists, whose members would include Kandinsky, Mondrian, Arp, the sculptor Vantongerloo, and later the English artists Ben Nicholson and Barbara Hepworth. Although the ideas behind the members' work were different, abstraction was on the way to becoming an established international tendency.

For some artists, the abandonment of the recognisable subject

was simply an experiment designed to see whether painting could work like music. But for others, it was significant of a whole philosophy, as we have begun to see. For them, the world before them was not real at all, but was just the outward form or casual projection of the 'real world', which existed behind it and was a sort of mystical abstraction. The real world seemed too accidental, too individual to be the ultimate answer. So they rejected it and tried to paint what they conceived to be the inner truth, which, not being accidental, would be simple and geometrical. What this amounted to (since there could be no agreement on this invisible 'real' reality) was every artist exploring his own world – hence the manifestos, and the fact that the movements did not last long. The exploration of one movement was quickly taken up and developed in a new direction by another movement. Abstraction had started as selecting elements from nature, as Cézanne had done, but the word came to be used in a wider sense and to mean very different things to different people. We now use it for Kandinsky's expression of inner feelings, for Malevich's squares with supposedly no reference to feeling, for Constructivist explorations of space, for anything where we do not recognise the image at first glance.

MONDRIAN AND DE STIJL

The working life of the Dutch painter Piet Mondrian spanned the years 1895 to 1944 and his work influenced the whole field of twentieth-century design. Mondrian's early pictures show how, without knowing Cézanne's painting, he was looking for the same thing – that which is constant behind the accidents of appearance. Unlike Cézanne, however, Mondrian had a philosophy mainly based on theosophy. He believed that every particular thing we see, whether it be a landscape, a tree, or a house, has an underlying essence, and that these essences are, despite appearances, in harmony. The purpose of the artist was to reveal this hidden structure of reality, this universal harmony, in his paintings. His earliest pictures show him searching for this essence and harmony not far below the surface of what he could actually see.

We can see this very clearly in the tree series. *The Red Tree* is an

Piet Mondrian, *Red Tree*,
1908, oil on canvas,
70 × 99 cm, Collection
Haags Gemeentemuseum,
The Hague, © SPADEM.

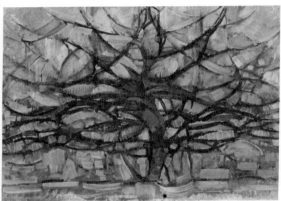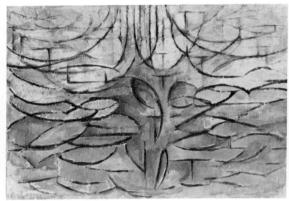

above
Piet Mondrian, *Grey Tree*,
1912, oil on canvas,
78.5 × 107.5 cm,
S. B. Slijper collection,
Haags Gemeentemuseum,
The Hague, © SPADEM.

above right
Piet Mondrian, *Flowering
Apple Tree*, 1912, oil on
canvas, 78 × 106 cm,
Collection Haags
Gemeentemuseum, The
Hague, © SPADEM.

expressive painting in bright Fauve colour; we are very conscious of
the life in the tree and the grass pushing up around it. In the next
tree painting the branches push right to the edge of the painting,
starting to 'lock' the tree into its space. The tree and its own life is no
longer the subject, but the tree and its relation to everything else.
The activity of the tree is now seen as part of a universal action, and
this is expressed by depriving the tree of its local character, in fact by
making it abstract. Mondrian's search for universal harmony is
carried even further in the other tree painting. The trunk and the
branches become straight lines and curves. The branches are the
movement, the spaces between them offer opposition. The branches
tense against the spaces in the way that sand-dunes were braced
against the sea in Mondrian's earlier work, to convey a balanced
opposition of forces. He was very sensitive to any lack of balance in
things like windmill sails, which were too strong for the void around

them, or a horizon that seemed to clamp down too heavily on the sea.

Mondrian went to Paris in 1911. He came to know Cubism in its late stage and he liked it. As a new way of looking at reality, though a very different one, it confirmed the path that he had been taking. But when he saw Synthetic, or Collage Cubism develop, real things actually being stuck onto the painting, then he did not want to follow. He could no longer represent real things in his paintings because they aroused feelings, and he thought feelings obscured pure reality – the same line of thinking that the Russians were to come to a year or two later (page 29). For them abstract painting was a step towards pure awareness; for Mondrian it was a step towards that universal harmony and balance which he believed he could reveal only by discarding particular images in favour of universal ones. Even with abstract shapes he still felt that he was expressing something too completely, that a place should be left for the divine and the mysterious. Like Kandinsky, he was very much attracted to mysticism, and remained a member of the Theosophical Society all his life.

The Russian Suprematists had influenced another Dutch painter and theorist, Theo van Doesberg and, in 1917, he and Mondrian became co-founders of a movement called De Stijl. The name was again that of a publication and the movement included, among others, the painter van der Leck, the sculptor Georges Vantongerloo and architects J. P. Oud, Rob van t'Hoff and later Gerrit Rietveld. The style of the movement was called Neo-Plasticism and was based on the idea that the essentials of something can be shown in the simplest possible way with horizontal and vertical lines and primary colours – that if you analyse and simplify something enough you will get to the essence of it.

Mondrian's paintings of the twenties and thirties discarded diagonals and curves because they 'pulled' the observer into the picture, whereas horizontals and verticals make a barrier that reduces contact between observer and canvas. The use of horizontals and primary colours produced clear, bright, powerful structures with that equality and balance that were for Mondrian a blueprint not only for painting but also for living. His painting had developed from his own view of nature to an idealised view of a whole universe where everything combined to give unity, practi-

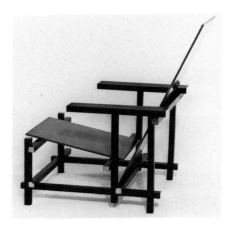

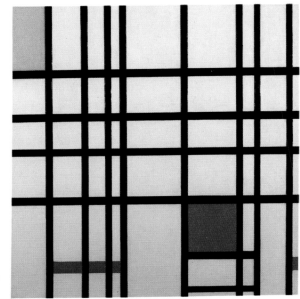

above
Gerrit Rietveld, Red, Blue
and Yellow Chair, 1918,
painted wood, Collection
Stedelijk Museum,
Amsterdam.

above right
Piet Mondrian,
Composition with Red,
Yellow and Blue, 1939–42,
oil on canvas, 72.5 × 69 cm,
Tate Gallery, London,
© SPADEM.

J. P. Oud, Project for
Seaside Housing
(Straandboulevard), 1917.

cality and beauty. In his philosophy the individual would dissolve in
a universal life and culture.

In architecture, the rectangular forms of Oud's *Seaside Housing*
linked very clearly with Mondrian's painting. Their stepped-back
shape reminds us also of Sant' Elia's building plans of 1914
(page 24). Oud's style matured under the influence of Cubism and
Futurism. The Dutch architect, van t'Hoff, also knew the Futurists
and admired Sant' Elia, but his building in 1916 showed the in-
fluence of Frank Lloyd Wright, the foremost American architect of
this century.

FRANK LLOYD WRIGHT

Before the turn of the century Frank Lloyd Wright had worked with
Louis Sullivan, the architect of some of the earliest high buildings.
Amongst Wright's first designs, when he started working on his
own, were the 'prairie' houses. Some of these were built in the
suburbs of New York and their horizontal emphasis was in great
contrast to the picturesque mansions that were usually com-
missioned by wealthy clients. Wright insisted that a design must be
individual to its site and purpose and that although the components
might be made by machine, the building must be more than the sum

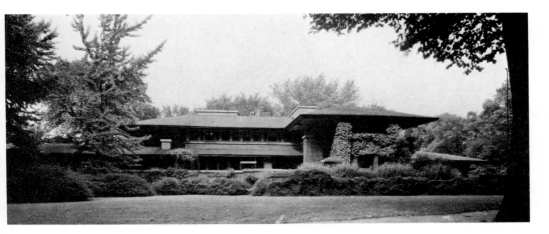

Frank Lloyd Wright, Martin House, Buffalo, New York, 1904, street view, photograph courtesy of The Museum of Modern Art, New York.

of machine-made parts. The client always had to accept his design totally. The prairie house was designed from the inside. A group of rooms opening into each other and onto terraces and balconies jutted into gardens to become part of the landscape. As early as 1911 Frank Lloyd Wright had established a teaching community at Taliesin, Wisconsin. He became the dominant figure in American architecture, though world recognition did not come until the late thirties. Even so his buildings had much in common with new architectural ideas in Europe from the twenties on, especially in the way materials were used and ornament rejected. The most important of these trends was centred on the Bauhaus group in Germany.

THE BAUHAUS

In 1903 Henry van de Velde, the Belgian painter and architect, had founded an arts and crafts school at Weimar in Germany. There was already an old-established school of fine arts there, and the idea of joining the two was considered. Van de Velde decided that the German architect Walter Gropius would be a good director of the combined schools, and in 1919 the Bauhaus was founded. The name Bauhaus means Building House, and building design and construction were at the centre of Bauhaus teaching.

At the beginning the emphasis was on craftmanship; there is no reference to machinery in their first publication. The preliminary course, lasting six months, was run by Johannes Itten, a painter with educational interests. The students were made aware in those first months of everything around them, colour, form, volume, texture,

35

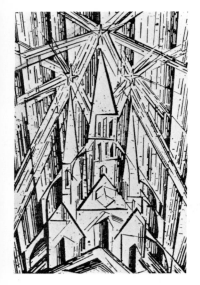

Lyonel Feininger,
Cathedral, 1919, woodcut,
30 × 18.6 cm, title page for
*Des Staatlichen Bauhaus in
Weimar*, by Gropius, 1919,
© ADAGP.

Paul Klee, *Storm Spirit*,
1925, pen and ink,
28.6 × 22.7 cm, Paul Klee-
Stiftung, Kunstmuseum,
Bern, © COSMOPRESS and
SPADEM.

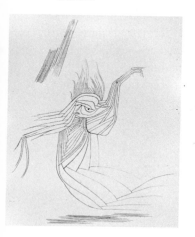

sound and scent. They studied the different characteristics of materials and tools. From that came the idea of working with the material and not imposing rules on it. Preconceived ideas were discarded as the students learned by following a process for themselves from the beginning.

The aim of the Bauhaus student was to make things that were both appropriate for their function and expressive of the maker's ideas. This liberation of the student's own ability was a departure from the academic teaching of the time, though it had parallels with the current Froebel and Montessori methods of education and their emphasis on direct experience. The preliminary course became the core of the Bauhaus method. It was followed by a three-year apprenticeship in a particular craft, then a period of study in architecture to gain a Master's diploma.

Various teachers were appointed, many of whom were painters. Lyonel Feininger came in 1919; he had been part of Orphic Cubism and had also exhibited with the Brücke group (page 16). Kandinsky came in 1922; Paul Klee, who came in 1921, was both a painter and a musician. Cubism had shown him new possibilities of relating shapes. He began by relating lines and colours to each other to achieve a balance and found that shapes and overall composition came almost on their own, as if he had allowed the pen to draw by itself. He 'takes a line for a walk', starting with a dot that moves and becomes a line; he adds lines to make planes and flat spaces, and then more lines to make three-dimensional forms. Both Klee and Kandinsky were interested in children's art because they conceived it as expressing the reality behind what was seen. Much of Klee's work looks childlike. We sense his pleasure in putting colour on shapes which suggest houses, then adding a tree to make the shapes look more like houses. This is in line with the Bauhaus preliminary course, where the student goes back to fundamentals and develops from simple beginnings. Klee was interested in science and was able to combine ideas with practical work in a way which made him a valuable and important teacher.

Kandinsky, Feininger and Klee were all mature painters when they were appointed to the Bauhaus. When van Doesberg and Oud came in 1922, De Stijl (page 31) ideas were reinforced. The Constructivists (page 29) had by now become a European movement

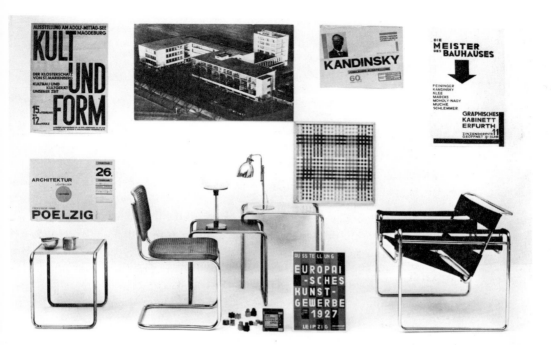

Bauhaus Designs,
1919–33, composite
photograph of items in the
Collection of the Museum
of Modern Art, New York.
Items shown are: posters,
the Bauhaus buildings,
tablecloth (framed), tables,
chairs, lamps and ashtrays.

which included the Hungarian sculptor Laszlo Moholy-Nagy who was appointed to the Bauhaus in 1923 to take over the preliminary course from Itten. These influences changed the emphasis from craft work to industrial design. The machine was recognised as the modern medium of design, although Gropius still felt that craft was a necessary part of training for industry. From 1924 onwards, the shapes and forms, chosen because they fitted so well the function of the building or object, seemed to add up to a recognisable Bauhaus style.

In 1926 the Bauhaus moved to Dessau. From the beginning the residents of Weimar had found the students wild and undesirable. Now official harassment was added. The school was opposed to tradition, international in outlook and did not fit in with current National Socialist (Nazi) views in Germany. It was closed in 1933. But the Bauhaus had, during the 1920s, assumed leadership in architecture and design. It had made a great contribution to international style and, as we shall see, its influence was to continue in the years ahead as its members were scattered abroad.

4 Fantasy and the subconscious

In 1906 an Italian painter Giorgio de Chirico visited Germany and was impressed by the sinister qualities of German romantic painting (page 14). He went on to paint still lifes and landscapes which, in spite of their precise technique, were full of uncertainty and unease. They seemed empty and unresolved, even menacing, as if de Chirico was echoing the negative and destructive feelings of the years preceding the First World War.

Giorgio de Chirico, *The Nostalgia of the Infinite*, dated 1911, painted 1913–14, oil on canvas, 135·3 × 64.8 cm, Collection, The Museum of Modern Art, New York, © SPADEM.

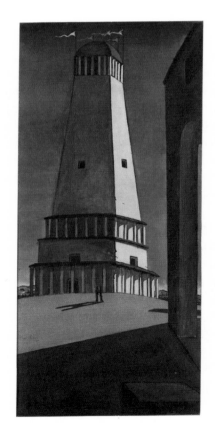

De Chirico was joined by other painters who took their subjects from the imagination, dreams and childhood fantasy. They were called Metaphysical painters. For them reason and logic had no place in art.

DADA

The First World War, which had so excited the Futurists, produced quite the opposite reaction in another group of writers and artists who chose the name Dada – which was infant language for hobby-horse, but being infant language could mean anything. These writers and artists believed that a society which could produce something as horrifying as the First World War was an evil society whose philosophy and culture should be totally destroyed because it was socially and morally bankrupt.

Dada was an attitude rather than a style; it was an international literary and artistic movement from 1915 to 1922. It was founded by the painter Hans Arp, the poet Tristan Tzara and other writers at the Café Voltaire in Zürich where the Dada artists first gave performances of bizarre music and dancing. At about the same time a similar group was formed in New York by Marcel Duchamp, Man Ray and Francis Picabia. Later, in 1918, in Lausanne, the two groups joined and issued a manifesto and a magazine.

The Dadaists set out to destroy established art in several ways. They mocked the art objects that had been venerated for centuries. They took everyday objects and presented them as art objects by exhibiting them. Duchamp submitted a urinal as a piece of sculpture, he titled it *Fountain* and signed it R. Mutt. It was rejected for exhibition in New York in 1917 and Duchamp, who was on the entry committee, issued a statement through a friend saying that whether Mr Mutt had made the fountain himself or not was immaterial, what mattered was that he had chosen it. What he was saying was that established art meant nothing any more, that chance had as much meaning and made more sense than the art of a rotten society. Arp made a chance collage by throwing pieces of paper together so that the result was accidental, a very different process from the Cubist collages of the preceding years.

The painter and poet, Kurt Schwitters, who had left Hanover as a refugee about this time also made collages of objects found by chance, which he called Merz. He chose the word Merz as his trademark. It stood for freedom in the cause of creation, but freedom with its roots in traditional disciplines, an attitude which did not fit in with true Dadaist anarchy. Merz extended into music

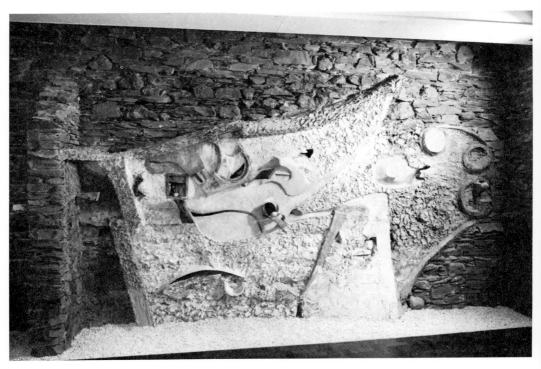

Kurt Schwitters, *Merz Barn*, 1945, Hatton Gallery Grant, University of Newcastle upon Tyne. © COSMOPRESS and SPADEM.
The plaster construction, built up on bits of wire and sticks 'grows' from the wall like an exotic fungus and shelters a collection of oddments: a china egg, a rubber ball, a segment of a cartwheel.

and poetry and into whole rooms covered with found objects. Schwitters later worked in England where he covered a barn wall in the Lake District with found objects. It has now been transferred to Newcastle University.

Certainly Dada succeeded in making scandals but, on the positive side, and like many of the other movements, it made people look at images in a different way. Dada paintings and objects forced the observer to question accepted realities and acknowledge the role of chance and imagination. After the war several exhibitions were held in Paris and the Dada artists made contact with André Breton, who was to become the spokesman for another movement, Surrealism. Eventually, by 1922, many of the Dada artists had become involved with Surrealism.

SURREALISM

Surrealism emerged both from Metaphysical painting, which took its content from the imagination, and from Dada, with its emphasis on the chance arrangement of objects. Surrealism was concerned

with exploring and illustrating the unconscious mind, rather than with destroying established art as Dada had attempted to do. The Surrealists decided that the rational and scientific viewpoint had been in the forefront for too long; they wanted to liberate the imagination and to make people conscious of its poetic, rather than its scientific aspect. The name Surrealist had been coined by Guillaume Apollinaire in 1917 to describe one of his plays. The art movement began in 1924 and continued into the thirties. The movement was organised, and its theories presented by the French writer André Breton. Breton studied Freud's work on psycho-analysis and considered himself a disciple, but Freud's uncovering of the workings of the unconscious mind and his scientific use of it was not at all the same thing as the Surrealist idea of total freedom of expression.

The roots of Surrealism go back a long way. At the beginning of the twentieth century, when the unconscious mind was so much written about, the *avant-garde* of literature and painting looked back to the fifteenth-century painter Hieronymus Bosch because in his paintings Bosch had translated medieval man's deepest desires and fears into symbols. Some of those symbols were traditional; others came from the imagination of the artist. In the Middle Ages these strong feelings were very near the surface and it was only a short step to make them visible in painting. Bosch showed in his time what Freud showed later and more scientifically – that the symbol can be the link between the conscious and the unconscious mind.

Bosch's Satan from his panel *The Damned in Hell* is not a conventional Satan. He has no horns, no tail, no evil expression. He is sitting on a stool pushing sinners into his beak, and they pass straight through him. Satan's head is the head of a day-old chick, which is very strange because we think of a chick as an innocent thing. This Satan is not deriving any pleasure from devouring sinners. He pushes another one down as though he doesn't really want it and because he doesn't really want it he is never going to be satisfied. He is indifferent to what he is doing and that is what makes him so awful.

Magritte's child, like Bosch's Satan, is also indifferent. He is well dressed and obviously does not go hungry, which makes it all the more disgusting that he is eating a newly killed bird. His face is a

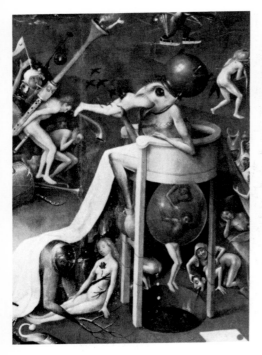

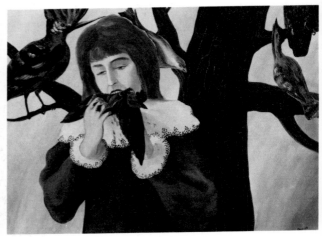

blank and he, too, is destroying for no reason; he has also gone beyond hope. He has been drawn from the same pool of common human experience and common human fear as the Satan, the pool that we call the collective unconscious.

Bosch and Magritte are separated by more than 400 years but they both use symbols to illustrate the same feeling of utter hopelessness.

Salvador Dali, another painter with a very precise technique, said that he had all the same tendencies as a psychotic person, the hallucinations, the visions, the obsessions, but that unlike a psychotic who actually believed his own fantasies to be reality he, Dali, was fully aware of the difference between the imaginary world and the real one. He brings his vivid personal fantasies into contact with the world by painting them and in *this* way they become real.

Like so many Surrealist images, Dali's soft watches have their origin in a pun. In this case a pun about putting out your tongue, *la montre moll*, which also means a soft watch. So watches are painted like soft tongues. Dali said that they were also masochistic objects, looking forward to a terrible fate. They waited on the shore knowing that they would be swallowed up by the sharks of mechanical time, just as the sole fish flattens itself ready to be swallowed by the shark.

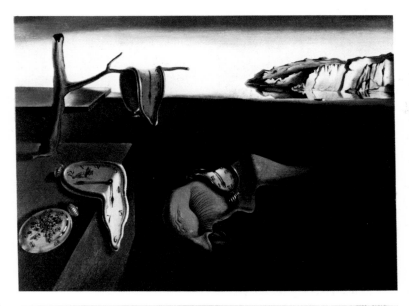

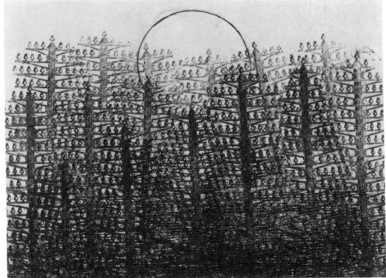

Possibly the greatest Surrealist artist was Max Ernst; he seemed to be a Surrealist by temperament. From an early age he had a fertile imagination, observing reality vividly and letting his fantasy play on it. Painting his fantasies and self-induced hallucinations seemed perfectly natural to him. Ernst often painted forests, forests that are tightly packed and sinister. The sun shines down on them, but does not penetrate: sometimes his cities are seen in the same way. These

43

paintings are subtly frightening; the more you explore them the more like a nightmare they become.

Ernst wrote about the forest, both as a perfect place for imagining, and as a place where a person was in danger of death. It was the mixture of fascination and terror that the young Ernst had felt on going into a forest for the first time. At first sight the pictures appeal as decoration but gradually the sinister qualities become evident. Ernst's forests are full of symbols, like those of the German Romantic painter Caspar David Friedrich (page 15) but his symbols are not so easy to analyse because they are not traditional. They are symbols from his own imagination and we are left to identify with them or not.

5 Beyond the movements

Of course not all painters, sculptors and architects joined whole-heartedly in the new movements. There were many who stayed with tradition and took as much or as little as they wanted from the new ideas. These included the School of Paris, a name for the many painters and sculptors, some French, some from other countries, who came to Paris because it was the centre for art. They lived and worked in the city from the beginning of the century until the thirties. Some of their work now seems very familiar. Because it is decorative and readable it is reproduced frequently on everyday things like calendars and birthday cards. When we look at the paintings of Chagall, Roualt, Soutine and Modigliani, there is much to move or delight us. We can see also how much they have drawn upon the ideas of the new movements.

There is space for only one example, *Paris through the Window*, by Chagall (page 46). Chagall came to Paris in 1910 from Russia, bringing his memories of a Jewish childhood and folklore images. He was influenced in Paris by Fauve colour and, to some extent, by Cubist treatment of space, but he painted in a style completely his own. His subjects are realistic in that we immediately recognise what they are, but he puts them together in unreal arrangements. The figures are often upside-down or in flight. Chagall was painting in this manner ten or twelve years before the Surrealists came to the fore as painters of fantasy. He went back to Russia for a few years and came into contact with the Suprematist and Constructivist movements but in 1920 he returned to Paris. By then his reputation was international.

SCULPTURE

Modigliani's friend and teacher, the sculptor Brancusi, came to

45

Marc Chagall, *Paris through the Window*, 1913, oil on canvas, 123 × 139 cm, Solomon R. Guggenheim Museum, New York.

bottom right
Constantin Brancusi, *The Kiss*, 1908, stone, height 58 cm, Philadelphia Museum of Art, Louise and Walter Arensberg Collection, © ADAGP.

below
Auguste Rodin, *The Kiss*, 1901–4, marble, height 180.1 cm, Tate Gallery, London, © SPADEM. Which is most expressive of closeness? Compare also Klimt's *Kiss* (p.19).

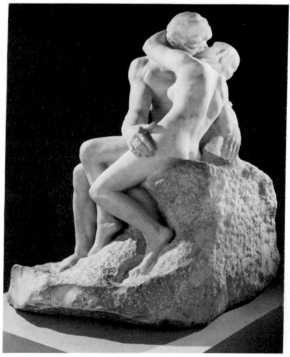

Paris from Romania in 1904. Brancusi's work was fertile and
inventive. In *The Kiss* the stone block is not much changed by the
sculptor; but he has made an effective image. Compare it with
Rodin's life-sized sculpture *The Kiss*. One is such a simple form and
the other so complex, but both are very expressive.

Brancusi used the egg shape, a shape that can easily be appreci-
ated by touch, to make sculpture for the blind. But this happy idea
was merely a consequence of his belief in the value of simple shapes.
Like Mondrian, he thought that all life could be reduced to essen-
tials and that then we would have the real truth. This even led him to
deny the individuality traditional to portraiture. He did several
versions of the dancer Mlle Pogany's head using the egg shape for
both the head and the eyes.

Jacob Epstein, who lived and worked in England from 1905, also
went to Paris and, like the School of Paris painters, took what he
wanted from the new movements. He met Picasso and his friends
and shared their interest in African art. He was also influenced by
Futurism. In his *Rock Drill* we are very conscious of the shudder-
ing machinery and 'noise'. Epstein's figures are recognisable, but
distorted to give the utmost boldness and strength of expression.
His work was controversial at the time because, like German
Expressionist work, it was brutal.

Epstein, in his turn, influenced the early work of the English
sculptor Henry Moore. In the late twenties Moore studied pre-
historic sculpture in the British Museum and was impressed by the

vitality of this ancient work. It was more important for his sculpture to be powerful than conventionally beautiful. For instance, he was impressed by sculptures whose makers had believed them to play a direct part in nature, such as Aztec images of the god of rain, who was supposed to water the crops, and represented thunder and lightning. This was man-made sculpture, but to the pagan mind it was part of nature. By the 1930s Moore was producing reclining figures that suggested the rugged north of England landscape in which he had grown up and been trained.

Moore observed and collected rocks, bones and pebbles with significant shapes, and he based his sculptures on the forms that they suggested to him. Sometimes he kept to the small scale of these natural objects; sometimes he carved them, or had them cast in metal, in a monumental size. He could work successfully to any scale. Moore always had a preference for carving rather than modelling, for feeling his way round the material and discovering which way it wanted to go. When he carved a piece of stone, it did not become something completely different; it remained a stone and part of the landscape though it suggested a human figure. This respect for material echoed Brancusi who had said earlier that his hands followed the thoughts of the material.

Léon Bakst, design for *Fedra*, 1910, Victoria and Albert Museum, London, © SPADEM.

THE DECORATIVE ARTS

In the early years of the twentieth century the 'decorative' or 'applied' arts of costume, furniture, jewellery, house interiors, graphic design, etc., tended to be rich in ornamentation. The Art Nouveau style (page 15) with its complex curving lines had become international by the 1890s. But, as happened with many other styles, it developed to a point where it began to deteriorate. There was a feeling that something simpler was needed.

The move to a greater simplicity was delayed, to some extent, by the work of Léon Bakst in the theatre. In 1909, Diaghilev's *Ballet Russe* came to Paris. The vivid colours of the Bakst costumes, the barbaric reds, green, purple, and above all orange, colours that echoed Stravinsky's harsh-sounding music, made a great impact and replaced the softer shades that had been in fashion. The oriental

patterns and shapes were also striking. Bakst had the skill to handle an excess of brilliant colour and ornament (though his imitators had not) and his ballet costumes and scenery kept a richness of ornament fashionable for longer than it might otherwise have been. It delayed the simplicity that was to replace it.

Perhaps the first signs of a new style are to be found in the work of the Scottish architect Charles Rennie Mackintosh whose designs for interiors were a simplification of the Art Nouveau style. The Wiener Werkstätte (page 20) artists admired Mackintosh, and may have been influenced by him in 1905, when they designed the exterior of the Maison Stoclet in Brussels with its simple forms and geometric ornament. The style which is beginning here has recently become known as Art Deco. It is a good name because it suggests the connections with Art Nouveau.

Charles Rennie Mackintosh, Interior of the Room de Luxe, Miss Cranston's Willow Tea Rooms, Glasgow, 1904, Hunterian Art Gallery, University of Glasgow, Mackintosh Collection.

René Lalique, Car mascot
in the form of a head, 1930,
glass, Victoria and Albert
Museum, London.

René Lalique, Lamp, 1925,
glass, Victoria and Albert
Museum, London.

Art Nouveau had not tried to come to terms with industry whereas Art Deco was a design movement *for* the machine age. It brought art and industry together in designs that could be mass produced inexpensively using the new materials such as plastics, vita-glass and ferro-concrete.

The First World War inevitably interrupted development in the arts but when it was over, in 1918, Paris became the centre of creative activity. In France, England and Germany, pre-war industries were almost at a standstill with reduced manpower, but France was very quick to start reorganising in the applied arts, so that she could once again be eminent in making things that required a high degree of quality, style and elegance.

René Lalique's work is a good example. He had been an Art Nouveau jewellery designer. In his pieces he had combined coloured glass with precious or semi-precious stones and his designs had been very much copied He was the designer of the Coty scent bottles and the face-powder box which was in use until the middle of the century. Lalique's lamps were often made from a circular or semi-circular sheet of glass with the design acid-etched on the back. The light was placed in the bronze base and shone up through the glass. His work had a very high standard of design and finish but it was widely available because he chose to manufacture large editions

Eileen Gray, Eight-panel lacquer screen, 1923, Victoria and Albert Museum, London.

to sell in the department stores rather than to make individual and expensive pieces for collectors.

By now the Cubist movement was beginning to have its effect, and there was an even stronger tendency to use geometric forms. Other factors backed this up: a new interest in the ancient Mexican civilisations, a revival of American Indian folklore, the musical *Hiawatha* in particular. This was also the Jazz Age, and the syncopated rhythms of the music were echoed in the zig-zag patterns of textiles, jewellery and interiors. In 1922 there was an exhibition of African sculpture in Paris: people were taking up the Cubists' interest in African masks. The tomb of Tutankhamen, with its treasure, was opened in 1922, and soon Egyptian design found its way into jewellery and furniture. There were reproductions of the throne-like chairs found in the tomb, and masks gave an exotic touch to interior decoration.

Furniture designers such as Emile-Jacques Ruhlmann, who had been established before the war, continued to make hand-crafted pieces based on simplified eighteenth-century designs. These were exquisitely made and were above fashion, but so expensive that they were only for the very rich. Paul Follot and Maurice Dufrene also used simplified eighteenth-century designs, but less expensively. They mixed these with new designs for interior schemes which were

Emile-Jacques Ruhlmann,
Dressing table, 1925,
Macassar ebony veneer
with calf leather surface,
Victoria and Albert
Museum, London.

above right
René Joubert and others,
DIM metal chairs, pre
1929.

available through the department stores to middle-income people.
There was also the new generation of designers, such as Joubert who
was perhaps the first of the modern designers who really did break
with past design and decoration when he started his own studio, the
Décoration Intérieure Moderne.

THE 1925 PARIS EXHIBITION

The Exposition Internationale des Arts Décoratifs et Industriels
Modernes, held in Paris in 1925, was organised to show the work of
the time. Nothing copied from, or inspired by, the past was to be
admitted. Of course it was not possible to cut out previous ages so
completely, but France wanted to prove that she was not tied down
to the past, or to endless revivals of the past. The exhibition showed
that France had broken away from Art Nouveau and that after
fifteen years of Art Deco there was again the desire for a change.
The exhibition created a demand for what was new; everything now
pointed towards even further simplicity. Economic factors were
limiting the market for the very expensive hand-made furniture and
interior decoration, and mass production had become quick and
cheap. Furniture could now be made with veneers, thin layers of a
more expensive wood attached to a frame or base of a cheaper one.
Plywood came into use, three or more thin layers of wood glued
together and able to be steamed into curves. Tubular steel was

Le Corbusier, Drawing of a project for the Maison Citrohan, 1920, © SPADEM.

another answer to the shortage, and therefore the expense, of good timber.

The new clean lines and muted colours, referred to by their makers as 'modernist', made a refreshing change, both from the sinuous curves and floral designs which had been worked over for too long, and from the assertive quality of Art Deco.

The *avant-garde* in France, artists who were ahead of the con- temporary trend, such as the architect Le Corbusier, silversmith Jean Puiforcat and interior designer Robert Mallet-Stevens, had been admirers of Bauhaus work and had felt its influence and taken up its ideas before it became international. Le Corbusier had, like Gropius, worked in the office of architect Peter Behrens who believed in good simple design for everyday use in buildings, furniture and utensils. In 1920 Le Corbusier designed the Maison Citrohan, a studio house that was mass-produced and comparable to a car in price and availability. (The similarity of Citrohan to the name of the Citroen car was no coincidence.) At the Paris Exhibition of 1925 Le Corbusier showed the Citrohan house with a garden terrace built round a tree. The interior was furnished with mass- produced furniture available for purchase by catalogue.

FASHION IN DRESS

Women's lives had changed considerably during the war years. New opportunities were open to them and they now wanted clothes for a more active life, for travelling in cars, playing sports and enjoying leisure. The heavy ornament and tight waists of the pre-war years were no longer suitable. By the mid-twenties, dresses in soft

materials fell straight from the shoulders, and hair was bobbed or shingled to fit under the fashionable cloche hat. The length of dresses was variable; legs had not been seen in pre-war fashion and now the designers were uncertain how much leg should be shown. The new simple dresses demanded simple jewellery, made in the new plastic materials such as bakelite, or combined with chromium. Of course precious stones and metals were still used but costume jewellery became acceptable. The motifs used for jewellery, face-powder compacts and cigarette boxes were still Chinese, and Egyptian, zig-zags, and rising suns, but giving way now to more austere geometric designs – following the same trends as architecture and furniture.

Paul Poiret, one of the most famous Paris designers, who had pioneered the new free styles for women, was also an interior decorator who commissioned artists to design fabrics for both dresses and furnishings. Indeed the painter Raoul Dufy was, until about 1925, better known for his fabrics than for his paintings. In complete contrast to Dufy's fabrics were those of Sonia Delaunay, with their patterns of squares, rectangles and stripes in bold colours. Her husband Robert Delaunay (page 10) had worked in the style called Orphic Cubism and Madame Delaunay had shared her husband's interest in colour theory. Her fabrics were known as *simultanes* because their colours were put together to react against each other.

Sonia Delaunay, Material with striped squares, 1924, © Sonia Delaunay and SPADEM.

Edouardo Benito, Fashion
drawing for *Vogue*, 1928,
© Condé Nast and ADAGP.

THE TWENTIES AND THIRTIES IN ENGLAND

The same influences that established Art Deco in France were felt
in England, though perhaps not as quickly. In the post-war period,
the bright colour for the home, the new freedom in clothes, were all
part of the optimism and belief in a better future.

The great architectural styles of the past continued to be revived
to give grandeur to public buildings but new ideas were emerging
for private housing. The Garden City with its English cottage or
Tudor-style houses grouped around greens or along curving roads
was an optimistic solution to the problems of overcrowding in cities.
It was an extension of the earlier Arts and Crafts movement.

The Egyptian and other exotic fashions already established by
French designers appeared in England especially in cinema build-
ings and in details like Brandt's lift doors for Selfridges.

The influence of the exotic, this time of the Far East, was also
found in pottery, especially in the work of Bernard Leach. He
studied in Japan and brought the knowledge of Japanese traditions
back to Europe. This led to a fresh appreciation of oriental forms
and decoration, much as the discovery of Japanese prints had done
in the nineteenth century. Leach worked at St Ives in Cornwall,
using local clays and glazes and giving full value to their character-
istics. In this way he and his pupils were like the Arts and Crafts
movement. William Staite Murray, who was the head of pottery at
the Royal College of Art, was also much influenced by the Japanese

55

Louis de Soissons, Houses, Welwyn Garden City, 1925.

below
Edgar Brandt, Lift doors for Selfridges, 1922–8, bronze, Museum of London.

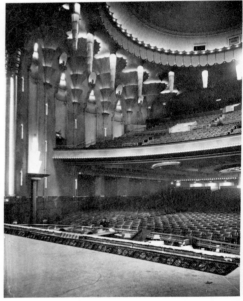

W. E. Trent, New Victoria Cinema, London, 1929.

Bernard Leach, Pottery vase, 1924, height 20 cm, Victoria and Albert Museum, London.

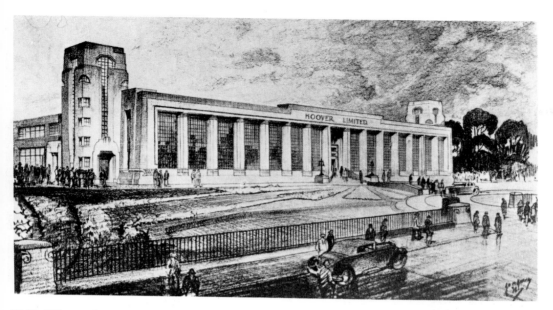

Wallis Gilbert and Partners, Hoover Building, London, 1930–2.

potter, Hamada, who had come back to England with Leach, and so this influence was passed on to a whole generation of student potters between the wars.

Modern functional design took a long time to come but by the thirties buildings like the Hoover factory were combining exotic details with a new symmetry and clarity. There was a striking simplicity too in Edward Johnston's and Eric Gill's lettering.

Edward Johnston, London Transport Underground sign, 1930.

The Paris Exhibition of 1925 had marked the coming of 'modernism'. Change of style is never clear-cut, but the trend in the twenties was towards a geometric simplicity. This continued into the thirties. In spite of the decline of Paris as an art centre for painters, France continued to excel in the decorative arts but by the late thirties there was again a growing fear of war. Political unrest meant that intellectuals, including artists, became refugees, and many settled in New York. The exodus hastened the decline of Paris and led to the establishment of New York as the new centre.

BRAQUE AND PICASSO AGAIN

Before turning to the post-war years we can look at what Picasso and Braque, who started the Cubist movement, were doing in the twenties and thirties after Cubism had been worked out. Braque's

57

Georges Braque, *Still Life*, 1925, oil on laminated board, 40 × 60 cm, Tate Gallery, London, © COSMOPRESS and ADAGP.

Still Life, painted in 1925, shows how, ten years after Cubism, his style once more reminds us of Cézanne. The tablecloth seems to have a life of its own and encloses the fruit and the goblet as a tablecloth would enclose the objects on the table if one looked down on it from a height. These objects are not pushed forward to make us re-examine their structure; they rest in their own decorative qualities, sharpened by the shadows and the geometric background. It is obvious that Braque liked and understood what he was painting here; there is a sense of intimacy and of harmony in the composition, quiet objects seeming to calm the restless cloth and gentle colour creating an intimate atmosphere The picture is in sharp contrast to one of Picasso's most famous pictures, painted in 1937.

Guernica is a frighteningly vivid painting of the bombing of a small Spanish town in the Civil War. Picasso was a Spaniard and a republican. This was a personal protest. At first glance the canvas looks chaotic but the composition is very firmly structured. There is no colour, only black, white and shades of grey; it is the shapes that show the confusion and terror by the way they are distorted. The woman with the baby throws back her head to scream, but the symbolic, trampling bull with his bullet tongue and knife-point ears is indifferent. These weapon-like parts of the bull contrast with the splayed hands of the woman which hold the baby and gesture hopelessly at the same time. The baby has a lifeless head and its vulnerable small feet emphasise the tragedy. The flash of the explosion is shown as an electric bulb lighting the scene even in daytime and casting a jagged shadow. The patriot in the foreground

Pablo Picasso, *Guernica*, 1937, oil on canvas, 349 × 777 cm, Collection, The Museum of Modern Art, New York, on extended loan from the artist's estate, © SPADEM.

is beaten and carries a broken sword. People fall on top of each other and a horse is brought down into the pile. A shocked spirit comes into the battle scene, amongst the women and children – and can do nothing. The lamp held out in the chaos is quite unable to compete with it. Somebody runs; but into the confusion, not away from it, and the figure on the right is trapped by jagged fragments of a building. Both in the composition and the atmosphere of this painting Picasso has caught one terrible moment of the horror of war. The action is taken to every corner of the canvas and seems to go on beyond it. The shattered forms, the atmosphere of panic, the symbols of disaster, come together to make *Guernica* one of the few genuinely public paintings, with a public meaning and a public language, of this century. In this it contrasts strongly with the experimental and private character of so many of the movements which preceded it.

6 Change of centre

We have looked now at the main movements which changed the story of art in the twentieth century: Cubism, Fauvism, Expressionism, Surrealism, and we have seen some of the characteristics of each. We have seen how these movements influenced architecture, sculpture, fashion, interior decoration, indeed how they changed the look of our world. It has also been obvious that there was a great deal of overlapping, of one group influencing another, and of artists trying out different techniques at different times. The story is not simple. Also there were many great artists working in the first half of the twentieth century who did not belong to any movement, and whose work needs to be studied separately. They cannot be fitted neatly into a book like this which tries to provide a map of the main trends.

We have concentrated until now on the arts in Europe because that is where the big movements started, but during the 1930s there was a change of centre. The next important development was to be led by artists in the United States. In order to understand the next stage, we have to look back again to the beginning of the century and to what was happening in New York.

PAINTING IN NEW YORK

At the beginning of the twentieth century a group of artists turned to painting scenes of city life in New York. Their pictures were not beautiful in the accepted sense but they did depict, to the increasing number of people who now lived in cities, the reality of their lives. These painters wanted their art to be something particularly American. A second group, more interested in the new trends in Paris, moved to New York to make closer contact with other artists. Both groups wanted to do something new; both were opposed to painting which drew on the old styles. They were an *avant-garde*.

The city-life group, who called themselves The Eight (but

were derisively known as the Ashcan School), were led by Robert
Henri. He taught a combination of the dramatic light and dark
of Old Master painting with the expressive brushwork of the
late-nineteenth-century German painters. This combination could
produce very lively painting. The Eight were concerned with
showing the city as something alive, something to be presented and
celebrated, just as earlier painters had celebrated nature. Some of
the group had studied abroad and several had been artist-reporters
in Philadelphia. For these painters the scene, or the object, was more
important than the painting style or technique. Life was more
important than Art. The Eight exhibited as Independents in 1908
and 1910 and were criticised for their coarseness in wanting to bring
everyday subjects into the drawing room. Even so discriminating
collectors began to seek their work and the public were interested.

The second group of artists gathered around Alfred Stieglitz and
his Photo-Secession Gallery at 291 Fifth Avenue, New York. The
gallery's name was a reminder of the German and Austrian artists
who had withdrawn from their academies a decade or so earlier to
make a new start. The Stieglitz group placed great emphasis on
individuality. Their work was varied and their reasons for belong-
ing to a Secession could be very different. Some had travelled
and worked abroad, absorbing the new movements in France and
Germany. Others had met visiting European intellectuals or artists
who had emigrated to America bringing new philosophies.

Whereas the city-life painters, under Henri, had taken their
realistic subjects from the growing cities and their squalor, the
Stieglitz group felt that industrialisation swamped individualism.
They turned to the European movements, in a sense they turned
back to European traditions, to make their fresh start. For them the
important thing was for the artist to express his individuality in his
own style.

The exhibitions held at 291 Fifth Avenue from 1902 included
photography, French painting from Cézanne onwards, and
American painting and sculpture. For a decade the 291 Gallery was
the centre of the *avant-garde*. Rodin's drawings, shown in 1908,
were the first exhibition of a modern artist in America; Matisse was
also shown that year. In 1911, the work of Picasso was shown, and in
1914 Brancusi was given his first ever one-man show.

Stieglitz also exhibited the American painters of his own circle
He knew that both they, and the European moderns, were
appreciated neither by most critics, nor by the public. Even so he
was dedicated to what he was doing, which was to try to modernise
American art. But it is important to recognise that the artists who
gathered round Stieglitz and exhibited at the 291 were not *against*
the rest of the society in the way that their European counterpart.
were. They were critical of the society in which they lived and they
knew that they were out of step with it. But they did not wish to
destroy it. Although they looked to Europe, they got on with their
own work in their own way.

THE ARMORY SHOW, 1913

Some of the artists of the Ashcan School, now members of the
newly-formed Association of American Painters and Sculptors
were ready for another exhibition to follow the Independents
exhibitions of 1908 and 1910. The new show, planned for 1912
would be organised by practising artists rather than officials. A
committee was formed of former Ashcan School painters and some
academic painters; the general tone was conservative. The choice of
a president was difficult and after several changes Arthur B. Davis
was appointed. He was a fortunate choice because he was respected
by the more conservative faction; he had been a member of The
Eight, and he was sympathetic to the 291 Gallery artists. He was also
interested in what was going on in Europe. The planned exhibition
took on a wider significance under Davis's leadership.

Davis went to Paris, Cologne, Munich, Berlin and London to
gather works for the exhibition and was able to show more than 1800
European works, mostly painting and sculpture. The earliest work
was a Goya miniature; and the French nineteenth century was
represented almost from the beginning to the end, by Ingres and
Delacroix, Daumier and Courbet, Corot and Manet, Cézanne and
the Impressionists, van Gogh and Gauguin. There was an emphasis
on the late-nineteenth-century French Symbolist painters, because
they were Davis's main interest. The Cubist and Expressionist
painters of the early twentieth century, Picasso, Braque, Kirchner

and Kandinsky, were shown. The Futurists would not show because they were not offered the right space, but their interests were represented in the works of Léger, Picabia and Duchamp. The sculpture of Brancusi and Rodin was shown. The selection was enormous, even though it was an incomplete picture of what was going on in Europe at the time.

In a way, the American entry was also incomplete because Max Weber, the artist who best understood Cubist theory, was not offered enough space and therefore did not exhibit. The city-life paintings of The Eight were shown, and so were the American subjects of the Stieglitz circle. However, all but the best of American work tended to look undeveloped beside the European painters who had been working out their theories so vigorously.

Those invited to the Armory Show, so called because it was held in the 69th Regiment Armory Building on Lexington Street, scorned both the American painters and the Europeans. They thought that the foreign painters were invaders bringing in un-wanted ideas. The press made great political capital out of it all and played up public fears that modern art was not only artistically revolutionary but dangerous. The critics and the wealthy collectors felt insecure because they did not understand what they were looking at, and thought that they were being made to look foolish. American artists who had taken up European ideas were derided for not developing an American culture. The exhibition aroused similar reactions when it toured the big cities and there were riots and demonstrations against it.

However the effect of this publicity was that the art of the twentieth century in Europe and North America became widely known all over the United States. Postcards found their way to people who would never have visited the exhibition and, just as important, twentieth-century art found a new kind of patron: educated people with a real interest in the work of their time, rather than the wealthy who traditionally collected European art.

THE DEPRESSION AND SOCIAL REALISM

The view of the conservative critics that America should be looking

Charles Demuth, *My Egypt*, 1927, oil on composition board, 90.8 × 76.2 cm, Collection of the Whitney Museum of American Art, New York. A familiar subject, grain silos, is presented in Cubist shapes and with Futurist lines of movement.

to herself, rather than following Europe in the arts, was endorsed and became more widespread after the American involvement in the First World War. This showed itself, after the war, in realistic painting of the American scene, and painting of what was rapidly disappearing because of industrialisation. It was a search for the American spirit and a gesture of independence. This should have meant that the artist was reflecting public feeling and would be appreciated for it. Instead people took the paintings as a criticism of the environment and the artist was no nearer to his public now than The Eight had been when they presented city scenes as a salutation to a new way of living, or the Stieglitz circle had been when they presented American subjects in their own individual way.

The American financial crash of 1929 and the Depression that followed led to an intense examination of society. Social Realism,

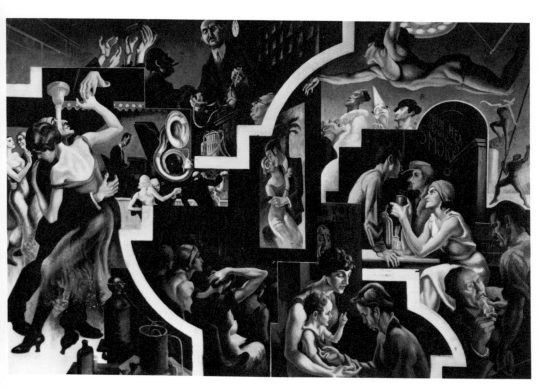

Thomas Hart Benton, *City Activities with Dance Hall*, 1930, tempera, mural from the *America Today* series at the New School for Social Research, New York.

the name given to painting like Thomas Hart Benton's, seemed the only relevant art. The government, under its New Deal, set up programmes to provide employment, including work programmes for artists to decorate public buildings. Because most of the jobs were on a large scale and had to have the required social subjects, much of the work was repetitive and conformist. Another federal project was the Index of American Design, a classified catalogue illustrated by Grant Wood, which greatly renewed interest in folk art. American folk art was now seen as something to be proud of and perhaps the real art of America. Through these work programmes the artists felt, perhaps for the first time, part of the community by being part of the work force.

Alongside the Social Realism of the thirties, other artistic ideas continued and overlapped. Abstract painting was one, and Stuart Davis was its principal exponent in the years following the Armory Show. Davis had been one of the Ashcan School. He had studied Cubism and was always aware of what was going on in Europe, but he was rooted in America. In his paintings he included everyday signs and symbols such as tickets and matchboxes. His subject was

65

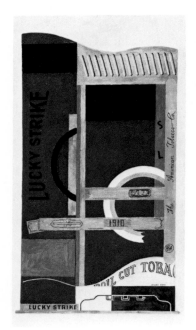

Stuart Davis, *Lucky Strike*, 1921, oil on canvas, 83.1 × 45 cm, Collection, The Museum of Modern Art, New York, gift of the American Tobacco Company, Inc.

American life at that moment, but he was aiming to reach the ideas and emotions behind the life of the moment and not to portray the American scene realistically.

THE EXODUS FROM EUROPE

During the thirties many more teachers and artists came from Europe to America, some on visits, some to stay. From 1929 onwards European artists exhibited in the Museum of Modern Art and there was a museum of non-objective art, mostly abstract, founded by Solomon R. Guggenheim, which housed an important collection of Kandinsky's work.

In 1933 the Bauhaus (page 35) finally closed under political pressure and several of its teachers, among them Gropius, Feininger, and Moholy–Nagy, left Germany and eventually settled in the United States. Josef Albers, who had taught on the Bauhaus preliminary course, went to Black Mountain College in North Carolina, where many leading artists of the forties and fifties were to go as visiting teachers. Gropius formed the New Bauhaus in Chicago in 1937.

Another distinguished teacher from Germany who became

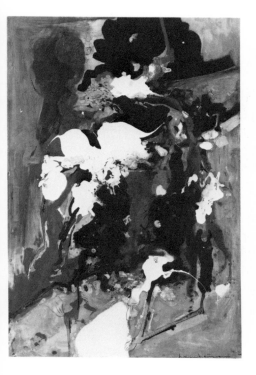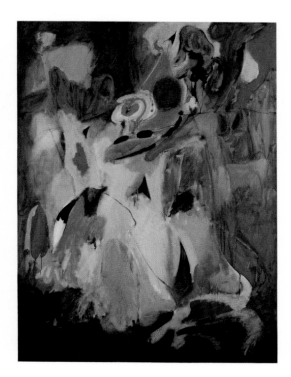

very influential was Hans Hofmann, who came to teach in California and remained to open his own school in New York in 1933. Hofmann had been greatly influenced by Matisse in the early years of the century and he wished to keep a similar expressive approach in abstract pictures, though he abandoned Matisse's lively delineation and allowed his paint to drip and run on the canvas. Other artists who came to America in the thirties were the Surrealists, Max Ernst, who came in 1939, and Dali, Masson and Joan Miró in the forties. Mondrian went to live in New York in 1940, Gabo in 1946.

Their arrival did much to make New York a new artistic centre. It might have become mainly a colony for European expatriates, but some artists succeeded in making a link between America and the European movements. One of the most prominent of these had in fact been in the United States since 1920. His name was Arshile Gorky, and he became one of the progenitors of the important mid-century movement, Abstract Expressionism. Gorky had arrived in America as a young boy. Because he was too poor to buy paints, he concentrated on drawing in his early years. This emphasis on line continued in the expressive outlines of the figures in his paintings. Gorky never wanted to become an 'American' painter; he always

felt tied to Europe and quite consciously imitated Cézanne, Picasso and Kandinsky as the modern masters. His selection from other artists was always very personal. He did not simply follow a style, rather he identified with the artist. During the late twenties and early thirties his work became more free and personal. His amoeba-like shapes resembled those of the Surrealists but the painting technique was expressive, like Hofmann's.

The design of *Waterfall* certainly seems to fall down the canvas but the atmosphere is more reminiscent of water rites and mysteries and the gentle dreamy colour accentuates this atmosphere. It is in the texture that this work differs from Surrealist painting. Some parts are lightly painted and smooth but there are also rough scrumbly passages and paint that has been allowed to run and form drips. These different combinations of texture and colour give great vitality to the picture. Gorky has taken what he wanted from past styles and produced a new combination, that of a seemingly careless technique with abstract forms and traditionally harmonious colour. This is not a wild torrent but a controlled waterfall changing its mood as it falls.

This combination of Surrealist space and forms and the expressive use of paint was developed by some of Gorky's contemporaries and came to be known as Abstract Expressionism. The Abstract Expressionists were all very different, and barely formed a movement, but the name does attempt to suggest what they had in common. The artist who best exemplified the style was Jackson Pollock.

7 Into our time

JACKSON POLLOCK AND MARK ROTHKO

Jackson Pollock was a farmer's son from Wyoming who went to art school in Los Angeles and then studied painting with Thomas Hart Benton in New York. In the thirties Pollock was open to many influences. He admired Cézanne and Picasso and painted in a Cubist manner. He also admired Kandinsky's abstract and expressive paintings. Yet he thought that American painters had become muddled in following European painting. He particularly admired Albert Pinkham Ryder, the late-nineteenth-century American mystical painter, and was interested in the Mexican muralists like Diego Rivera. Pollock produced similarly large-scale work for the New Deal programme in the thirties. Perhaps the most important

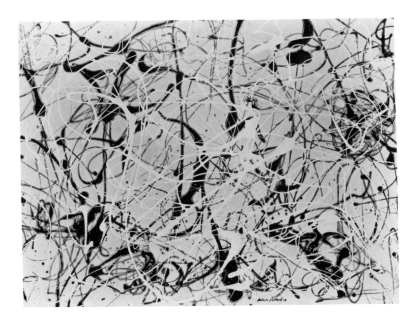

Jackson Pollock, *Number 23*, 1948, duco on card, 57.5 × 78.4 cm, Tate Gallery, London.

influence came with the arrival of Surrealists, with their idea that the source of art was in the unconscious.

By 1940 Pollock was painting large pictures with a continuous composition that was finally determined simply by cutting the finished canvas where he chose. There was still a certain amount of recognisable subject, but the main interest was in the fact of its being a painting and this led to an exaggeration of all the signs of painting. Pollock would put an unprimed canvas on the floor and add layer upon layer or, rather, stream upon stream of paint, so that the final effect has considerable depth. It is as if one were looking through coils of barbed wire or, in the lighter works, standing behind a waterfall. But there is not just one way of looking at a Pollock. His work has been called painting of confrontation and at times his enormous paintings seem to invent and confront some new (and not very hospitable) nature. At other times his coils of black paint over yellow indicate an almost aggressive optimism; and at other times still his canvases convey nothing but a record of the painter's activity, as if his own existence is enough, and indeed all that he believes in. In fact his paintings have been seen as having no other content than an affirmation, in the absence of all other certainties, that at least the painter's action is real – hence the name often given, Action Painting. There cannot be the same uncertainty, however, about the work of another Abstract Expressionist, the Russian-born Mark Rothko.

His paintings are as difficult to look at as Pollock's, but not because they offer as many interpretations. It is more that their meaning is one we do not always want to acknowledge. In his mature style, his paintings consist of variations upon a few very simple forms, rectangles of colour suspended in coloured space, or forms which frame voids, or curtains of dark behind a rising ground. These forms were intended, and are often felt, to have a religious symbolism. That does not quite explain them: it is more that they represent what man's religious sense feels like when he knows no religion. Rothko's abstract spaces are like houses of the spirit, in which windows look out on nothing, all exits are closed, and the way forward is blocked by some gigantic, impassable weight, like an idol, hovering or advancing towards you. In depicting, especially in his late paintings, this sense of spiritual despair, Rothko discovered that

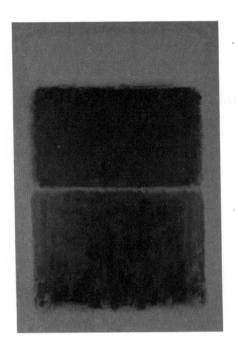

Mark Rothko, *Light Red over Black*, 1957, oil on canvas, 232.7 × 152.7 cm, Tate Gallery, London.

he had touched a deep chord in many people. But such a level of hopelessness could not have only artistic consequences: in 1970 Rothko took his own life.

ABSTRACT EXPRESSIONISM

Anyone looking at the best modern art will sooner or later ask himself how it compares with the art of the past. This is a dangerous temptation, because you tend to concentrate on what artists lack, rather than on what they have. Modern paintings can contain so many negatives: no representation, no depth, no belief. It is not that these paintings contain no subject, because some are profound, and others are intended to be. But if modern artists partly express the impossibility of continuing the rich language of meaning and belief which belongs to the past, we should also accept that their paintings may not be as great. A painting that expresses man's isolation may be less of a painting than one which reverberates with responses to the external world.

Great claims have been made by art historians for the position of the Abstract Expressionists, including such artists as Barnet Newman, Robert Motherwell and William de Kooning, all working

in New York. This is something about which it is too soon to decide. It may simply be that we ought not to compare them with the painters of the past, because there can be no objectivity. Also, it is hard to forget that the paintings of artists like Pollock, Rothko and de Kooning are now worth huge sums of money and are displayed in all the major museums. But this might have something to do with the need for cult objects in our society, the need for things to spend large sums of money on.

When thinking about modern art, too, we should always try not to get carried away by admiration for courageous and imaginative artists, or by a fascination with the success that the leading American painters command. The conditions in which they are trying to work, despite the sympathy they receive from all quarters, are not such as help to produce art. There is enormous pressure on them to innovate, to become over-night successes, but not to consolidate; to listen to the voice of fashion rather than to that of enduring values. In the centre of all this activity is the problem, for them, of *what* to paint. There is nothing much left to rebel against; yet mere continuance of the past is unthinkable. Just 'art'? But 'art' is only an abstraction, derived from looking at works of art that already exist, and were often painted for very definite purposes. We can only marvel at the resourcefulness of twentieth-century artists in finding new things to do. Some of their ideas, which it is really too early to assess properly, will be described in the remainder of this book.

Supposing, then, that we forget the glamour of New York as the new art centre and even the need of art history for 'great centres'; forget the unchallengeability of financial value and look at a few more of the paintings themselves.

POST-PAINTERLY ABSTRACTION

By the sixties the fashion had moved away from Action Painting to a cool impersonal abstraction, which was labelled Post-Painterly Abstraction. The painting of the sixties looks machine-made. It is still large but the personal brushwork has disappeared; the colour is flat, bright, and orderly. The tensions set up by the shapes and

colours are very subtle. The aggressive quality of Action Painting
has given way to something much more reserved, to painting which
is part of a wall, and not a whole environment that overwhelms. We
can see something of Mondrian and the Constructivists in the work
of artists such as Frank Stella and Kenneth Noland.

The sculptors also followed this trend. David Smith, working
alongside the Abstract Expressionists in the fifties, had made
drawings in wire. These sculptural collages came from his study of
Constructivism (page 29), but they were Surrealist in atmosphere,
telling a story. Smith had also known the abstract work of Stuart
Davis and started building up his paint to make reliefs on a canvas
base. These abstract and expressive elements came together in his
sculpture when, in the sixties, he started making big constructions
of scrap iron and pieces of steel which were meant to be sited out of
doors, reflecting their surroundings and the weather. These big
works cost a lot to produce and needed factory rather than studio
production.

OP ART AND KINETIC ART

European painters such as Bridget Riley and Victor Vasarely took
up the Post-Painterly trend in their own way. Whereas the colour-
graded squares and circles of Stella and Noland had a mathematic-
ally controlled appearance, Riley and Vasarely used wavy lines and
geometric patterns and combinations of colours that dazzled. The
relationship of the image to its ground gave the appearance of
movement. These paintings, dubbed 'Optical Art', have no obvious

73

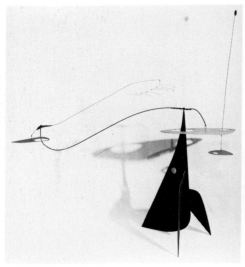

meaning and seem concerned only with visual disruption. This does not lead to total disintegration, instead the image keeps reforming before our eyes. Op Art led to Kinetic Art, where the work had movable parts which were set in motion either by air currents or machinery. Sometimes these movements were reflected by a beam of light onto a wall or screen; sometimes the spectator had to be involved in working the machinery. But if the work of art can move, why have an art object at all? The spectator's involvement with art has been taken further and a performance, a piece of theatre or a happening is presented as a work of art. All this looks back very strongly to Dada objects and to the cabaret performances of the 1930s.

One invention of moving art which gives pleasure on many levels is the 'mobile'. Created by Alexander Calder, the idea came from wondering how Mondrian's rectangles would look if they could move. Calder first experimented with hand-movable shapes and from 1932 onwards he suspended his amoeba-like shapes so that they moved in a draught of air. These irregular shapes moving gently in the air currents remind us of the Constructivist idea that art could represent life by constantly moving and changing. Others who took up Kinetic sculpture were American artists, in particular the South American Orteros whose large environmental sculpture is constructed to move in the sun and wind; it is landscape, science and art combined.

Andy Warhol, *Marilyn Monroe*, 1967, screenprint, 91.4 × 91.4 cm, Tate Gallery, London, © SPADEM.

POP ART

Painters who had been students in the forties reacted in the sixties against Abstract Expressionism by producing images of everyday things using the techniques of film, television advertising, newspapers and magazines. This was called Pop Art. Perhaps the artists wanted to reflect the urban life which so many people led, to keep up with the times, and to make art the same as life. Pop Art was full of the 'super-real' things that batter our vision every day, and though it should have broken down barriers between life and art, it did not. Rather it seemed that art was turning on itself, becoming a matter of careful selection and careful studio techniques. If subjects apparently have no meaning, then their purpose becomes esoteric. Too great a freedom of choice of subject had isolated the artist once again. The figures in Pop interiors seem to be just as much alone as the dream figures in Surrealist painting.

It was not new to present everyday objects as art; the Dadaists had done it to show their disgust with traditional works of art. Stuart Davis had done it in the twenties to catch the life of the moment. Now Andy Warhol was doing it and, like Davis, using graphic techniques. Warhol took a familiar object or person and multiplied it in rows with slight differences in the printing, so that the eye has to follow the lines of repetition and notice the distortion. Marilyn Monroe can be reproduced in rows, distorted, manipulated or destroyed, by means of graphic techniques. Perhaps Warhol is reminding us that these things can also be done to a person. Pop Art tells a story, both in the subject and its connections, and in the way the graphic processes change and are superimposed one upon another.

75

Morris Louis, *Vav*, 1960, acrylic on canvas, 260.4 × 359.4 cm, Tate Gallery, London.

Robert Morris, *Untitled*, 1967–8, red felt 457 × 183 cm, Detroit Institute of Arts.

Another innovation of the sixties was the shaped canvas. The concern with the motif here was so great that the background was cut away altogether because it was superfluous. The shape of the subject, for example a triangular flag, is the shape of the whole painting; there is no background. This is a yet more drastic attempt to do away with depth, to make a complete break with the Renaissance idea of perspective. Even so, in some of these paintings contrasts of colour create depth and individual expression overrides the theory. Another way of dispensing with background in the sixties was to paint directly on raw canvas so that the paint sank in and became part of the canvas. Morris Louis let veils of colour flow down his canvas in thin transparent layers. The sculptor Robert Morris achieved a flowing movement in another way. His pieces of felt are fixed to a wall and flow down to the floor, twisting as they fall. Once again there is no background. The felt and its shadows create an effect of mystery.

REALISM AGAIN

Alongside the explorations and developments of the sixties, realistic portrait and landscape painting continued. Social Realists used the photograph for reference, and it was important that it was not even a good photograph; the completion had to take place in the painting. The photograph was often used months after it was taken and was

Don Eddy, *Untitled*, 1971,
oil on canvas,
122 × 167 cm, Ludwig
Sammlung, Neue Galerie,
Aachen.

often black and white so that the colour and atmosphere of the painting bore no resemblance to the original scene. Don Eddy's *Untitled*, 1971, is a painting in colour made not from life but from black and white photographs. The artist is interested in setting up spatial tensions on a flat canvas and in working out his own colour system.

This work shows little interest in the subject, despite the precise treatment. It is really another attack on the values of painting because it can reduce the subject to accident, and the painter to a machine.

8 What do we make of it all?

When we look at the art of our own century we often see something that looks new and different. If we know a little of the history of art in the twentieth century we can recognise that what seems different is often a combination of old and new ideas. We can see what has been taken from the past, how it has been used, what is new, and what the artist has emphasised in the combination. This can help us to understand and enjoy what the artist is doing, although it will not tell us everything about the painting or sculpture or architecture. There is always an element of mystery in any individual creation.

Nowadays we often see works exhibited which, in the past, would not have been called 'art'. And we wonder, what is art, and what is an artist? That is what the twentieth century has been trying to discover. After so many experiments and movements the conclusion seems to be: art is what anybody chooses to present as art; it is human workmanship. Artists are people who respond to what is around them and who put their reaction down in their own 'handwriting' – or people who can make tangible and visible their inner reality and their imagination. Since we all share everyday reality, and we all have imagination, we can often identify ourselves with the artist and with what he has made. In that sense the artist speaks for all of us even though his creation is personal to himself.

On the other hand, the artist can often seem out of tune with the everyday world. Perhaps this is because he shows us what we know and do not want to acknowledge; perhaps because he shocks us with something that we are not capable of acknowledging. If, however, he tells us only what we already know and understand, we are somehow not satisfied. We want him to take us further. We need his exploration in art just as we need exploration in science or music or literature. The artist holds a mirror in front of us and makes us look, really look, at what is around us. We have to make connections with the past, with the other arts, and with our own imagination. Enjoyment may be instant or we may have to work at it, but the artist has

Art is what anybody
chooses to present as art.'

Jean Dubuffet, *Spinning
Round*, 1961, oil on canvas,
97.3 × 148 cm, Tate
Gallery, London, © ADAGP.
The figures are scratched
into thick paint. They
remind us of children's
drawings, seemingly
accidental. But is there a
deeper meaning?.

Mark Boyle, *Land Art*,
1967, mixed media.
Boyle handles the earth
itself and puts bits of it on
the wall so that we begin to
notice the shapes and
texture usually ignored
beneath our feet.

Antonio Tapiès, *Garnet
Velvet* 1963, oil and felt on
canvas, 161.5 × 161.5 cm,
Collection, Musée d'art
contemporain, Montreal,
© ADAGP.
Tapiès is also concerned
with making marks on the
surface of the paint,
moulding it with his hands.
But the final effect is to
make us concentrate on the
stillness, remote and
dignified, that follows the
action.

79

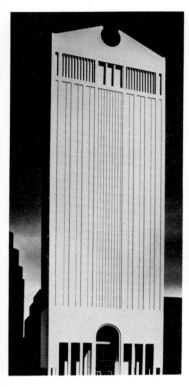

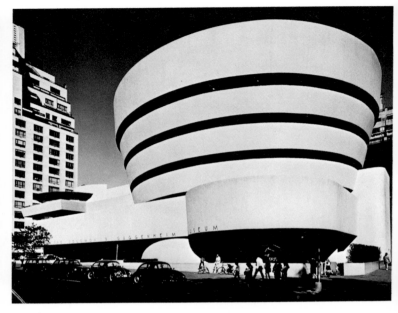

above
Philip Johnson, Model for
'Chippendale' skyscraper,
New York, 1978.
The entrance looks back to
Brunelleschi's fifteenth-
century Pazzi chapel. The
pediment hints at an
eighteenth-century
furniture design.

above right
Frank Lloyd Wright,
Solomon R. Guggenheim
Museum, New York, 1959.
Wright had continued to
work independently
throughout the century
(see p. 35). This building
can be compared to the
abstract paintings of the
sixties (p. 73).

given us something to hold in our hands or hang on a wall, and we
need to evaluate it for ourselves.

Twentieth-century explorations in art have broken many bound-
aries. New ideas, followed by new techniques and new materials
have led to new expressions in all the arts and have given us new
insights into ourselves and our world. In expressing ourselves we are
recording ourselves, confirming our identity. We have always in-
sisted on expressing ourselves, as individuals, using what has gone
before, what is around us, what is in all of us collectively and the
talent we have for making it tangible. In the twentieth century we
have been able to do this on a greater scale than ever before; we have
a long past to draw on. Science and technology have offered new
ways, and we have come to realise that other people's expression, or
art, is part of all our lives, part of everything that we see or touch.
Our understanding of what is built and painted and made at any
time is part of our understanding of ourselves.

Notes on artists

BALLA, GIACOMO, born Turin 1871, moved to Rome 1895 and remained there for the rest of his life; became a Futurist, signing the Futurist manifesto 1910 and painting such works as the *Dog on a Leash* 1912; later reverted to more traditional painting. Died 1958.

BOCCIONI, UMBERTO, born Reggio-Calabria 1882; became a Futurist under the influence of Balla and Marinetti and signed the Futurist manifesto 1910; was the principal writer on Futurist theory and the only Futurist sculptor. Died 1916.

BRANCUSI, CONSTANTIN, born Hobitza, Romania 1876; studied in Bucharest, Vienna and Munich and settled in Paris 1904; influenced by Rodin and Modigliani, he became one of the most eminent of modern sculptors, producing abstract works often of great simplicity. Died 1957.

BRAQUE, GEORGES, born Argenteuil 1882; worked initially as an apprentice house-painter, studied in Le Havre and then settled in Paris where he remained for the rest of his life; one of the Fauve circle 1905–6, became a friend and close collaborator of Picasso 1907–14, together creating Cubism; resumed painting 1917 after serious injury on war service, working independently on still lifes and figure paintings within a Cubist framework. Died 1963.

CÉZANNE, PAUL, born Aix-en-Provence 1839; abandoned study of law 1861 to study painting in Paris where he remained until 1870; exhibited with the Impressionists but never totally identified with them, developing structural analysis which had profound influence on Cubism; inherited his father's fortune 1886 and retired to paint at Jas de Bouffan in Provence; one of the most important influences on twentieth-century painting. Died 1906.

DALI, SALVADOR, born Figueras, Spain 1904; studied in Barcelona and Madrid; after passing through a Cubist phase, became a Surrealist, one of the best-known exponents of that movement, with his horrific, nightmare paintings, executed in meticulous detail; repudiated by 'traditional' Surrealists 1937–8; lived in America 1904–55 then returned to Spain.

DELAUNAY, ROBERT, born Paris 1885; influenced by Seurat and the Post-Impressionists and exhibited with the Blaue Reiter; primarily interested in colour, he applied principles of Cubism to use of colour, inventing Orphic Cubism. Died 1941.

DUCHAMP, MARCEL, born Blainville 1887, went to New York 1915; one of the original Dadaists, producing both paintings and 'constructs', he invented the 'ready-made' work of art. Died 1908.

DUFY, RAOUL, born Le Havre 1877; studied in Paris; initially painting in the Impressionist manner, he joined the Fauves 1905; particularly known for his seascapes and race-course pictures, he also designed textiles and ceramics. Died 1953.

EPSTEIN, JACOB, born New York 1880, went to Paris 1902, settled in London 1905; a monumental sculptor in stone and bronze, his powerful work has often been controversial. Died 1959.

ERNST, MAX, born Germany 1891; taught himself to paint while studying philosophy at Cologne; founded a Dada group in Cologne 1919, became a founder member of the Surrealist group 1921; lived in America 1941–56 but otherwise settled in Paris; one of the most important Surrealist painters, he also made collages and frottages. Died 1976.

GAUGUIN, PAUL, born Paris 1848; painted in his spare time until he gave up his job 1883, went to Tahiti 1891 remaining there almost continuously until his death in 1903; one of the most significant and influential figures in modern art, inspired by primitive art, he abandoned Impressionism for Synthetism, producing works in brilliant colours, defined by strong outline and aiming to be both decorative and expressive of emotion.

GOGH, VINCENT VAN, born Zundert, the Netherlands 1853; began painting 1880; went to Paris 1886 where he came under the influence of the Impressionists, and to Arles in 1888 where he worked in his own Post-Impressionist style based on colour expressing powerful emotions; became insane and had to be confined in asylums where he continued to paint until his suicide in 1890; was a great influence on the Fauves and the German Expressionists.

GORKY, ARSHILE, born Vosdanig Adoian in Turkish Armenia, 1904, fled before Turks 1915, arrived in America 1920; painted in New York from 1925; initially a Cubist, he later came under Surrealist influences and developed a style which heralded Abstract Expressionism. Died 1948.

GROPIUS, WALTER, born Berlin 1883; studied architecture in Berlin and Munich, director of the Bauhaus 1919–28; left Germany for England 1934, went to America 1938; chairman of Harvard school of architecture until 1952; as practitioner and teacher, he was one of the most important figures in modern architecture in Europe and America. Died 1969.

HEPWORTH, BARBARA, born 1903; trained in Leeds and London, visited Italy 1924–5, married Ben Nicholson, settled in St Ives 1939; an abstract sculptor, carving directly in wood or stone, but also in bronze in her later years. Died 1975.

HOFMANN, HANS, born Bavaria 1880; studied in Munich and Paris; taught in Munich from 1915 till 1932 when he left for America; an influential teacher in New York, initially of Expressionist and Fauve ideas and subsequently of Abstract Expressionism and Action Painting. Died 1966.

KANDINSKY, WASSILY, born Moscow 1866; abandoned a legal career to study painting in Munich 1896; joined Blaue Reiter 1911; returned to Russia 1914 to hold a number of distinguished academic posts; returned to Germany and taught at Bauhaus 1922–33; lived in France 1933 until his death; one of the first and most influential of the abstract painters. Died 1944.

KIRCHNER, ERNST LUDWIG, born 1880; studied in Dresden and Munich, was one of the founders of Die Brücke 1905; from 1917 until his suicide in 1938 lived in Switzerland, suffering from tuberculosis; influenced by the Fauves and by primitive art, he was one of the foremost German Expressionists and also made a large number of powerful woodcuts.

KLEE, PAUL, born Berne; 1879; trained in Munich, visited Italy 1901–2, associated with the Blaue Reiter 1911, taught at the Bauhaus 1920–33; returned to Switzerland 1933; a graphic artist as well as a painter, one of the most famous of modern artists. Died 1940.

KLIMT, GUSTAV, born Baumgarten, Austria 1862; studied in Vienna and led the Vienna Secession 1898; influenced by Burne Jones and Alma Tadema he was the principal Austrian Art Nouveau painter. Died 1918.

LE CORBUSIER, Charles Edouard Jeanneret, born Switzerland 1887; studied architecture in Paris 1908–9, in Berlin 1910–11 and settled in Paris 1917; a most famous and influential modern architect, noted particularly for his domestic and civic buildings, he designed buildings throughout Europe and North and South America, as well as making important contributions to town planning. Died 1965.

MAGRITTE, RENÉ, born Lessines, Belgium 1898; trained in Brussels; lived in Paris 1927–30 where he came into contact with the Surrealists and developed his own Surrealist style; returned to Brussels 1930; apart from a brief Impressionist period after the Second World War his style remained Surrealist. Died 1967.

MALEVICH, KASIMIR, born Kiev 1878 and apart from a brief visit to Paris in 1912 spent most of his life in Russia; invented Suprematism which reached its ultimate in his *White Square on a White Ground c.* 1918. Died 1935.

MATISSE, HENRI, born le Cateau 1869; abandoned law to study painting in Paris 1892–7; at first strongly influenced by Impressionism but in 1905

launched his Fauve style, and over the next nine years produced a series of masterpieces; settled in Nice 1914 where he produced his odalisques and still lifes and continued to produce sculptures, book illustrations and etchings; settled in Vence 1943, designing 1948–51 the whole decoration of the chapel of Dominican nuns there. Died 1954.

MODIGLIANI, AMEDEO, born Leghorn 1884, moved to Paris 1906, living in extreme poverty; influenced by African sculpture, by his Italian background and by the modern movements, he was nevertheless essentially original and atypical of his period. Died 1920.

MONDRIAN, PIET, born Amersfoort, the Netherlands, 1872, moved to Paris 1911, to London 1939 and from 1940 until his death lived in New York; founded De Stijl 1917 and became principal exponent of Neo-Plasticism; a theosophist, he sought to portray the absolute in his painting which is typified by geometrical shapes in white, black and grey. Died 1974.

MOORE, HENRY, born Castleford 1898; studied in Leeds and London, worked as a war artist 1940–42; subsequently made many large-scale works for official bodies both in England and overseas; his work has been dominated by directly carved, frequently massive, human forms.

MUNCH, EDVARD, born Loeiten, Norway 1863, worked in Paris and Berlin until 1908 when he had a serious mental breakdown; returned to Norway where he remained until his death; one of the foremost Expressionists, his work powerfully, often hysterically, portrays the anguish of the human spirit. Died 1944.

PICASSO, PABLO, born Malaga 1881; studied in Barcelona and settled in Paris 1903; in his blue period 1901–4 painted melancholy representational works of the poor; in his rose period 1905–7 worked on acrobats and harlequins; met Braque 1907 and with him developed Cubism which remained the framework of his painting; after 1925 developed some sympathy with Surrealism and his work began to reflect emotional intensity, despair which culminated in *Guernica* 1936 and others which dealt with the destructiveness of war; remained in Paris during the Second World War but after 1946 mainly lived in the south of France; deeply interested in primitive Egyptian and ancient Iberian art, Picasso was the most important figure in early-twentieth-century art; he was also a superb draughtsman and produced sculptures and ceramics. Died 1973.

POLLOCK, JACKSON, born Wyoming 1912; studied in Los Angeles and New York; painted successively in Cubist and Surrealist styles before developing as an Abstract Expressionist; perhaps the best-known exponent of the technique of Action Painting. Died 1956.

ROTHKO, MARK, born Russia 1903, went to America 1913, started painting 1926; originally influenced by Surrealism, he developed as an

Abstract Expressionist, his works are characteristically large blocks of colour with hazy edges. Died 1970.

SCHIELE, EGON, born Austria 1890; began to study painting 1906; much influenced by Freudian psychology which he sought to reflect in his painting. Died 1918.

WRIGHT, FRANK LLOYD, born Wisconsin 1869; worked with Louis Sullivan from 1888 to 1893 when he began in independent practice as an architect; evolved new forms suited to modern living and new structural techniques; particularly noted for his 'prairie' houses, he was a very influential teacher. Died 1959.

Glossary

ABSTRACT ART art which does not imitate or directly represent external reality whether or not reality was the artist's inspiration and whether or not the subject can be deciphered; based on the belief that colour and form have their own artistic value.

ABSTRACT EXPRESSIONISM non-representational, non-geometric abstract art, emphasising the physical act of painting as in the works of Arshile Gorky and Jackson Pollock.

ACTION PAINTING method of painting involving throwing, pouring, dribbling paint onto the canvas.

ART DECO design movement which brought together art and the machine age; produced characteristically geometric, streamlined, 'modernistic' ceramics, fabrics, furniture which could be mass-produced.

ART NOUVEAU decorative style, chiefly in book illustration, interior decoration and architecture which spread in Europe in the 1890s and 1900s; essentially ornamental with long sinuous curved lines, many tendrilled creeping plant forms.

ARTS AND CRAFTS MOVEMENT movement promoted by William Morris in the late nineteenth century, aiming to revive standards of design by a return to the ideals and skills of medieval craftsmen; artists were to work by hand on furniture, fabrics, wallpaper etc.

AVANT-GARDE group of painters, writers who at any one time are thought to be 'advanced' in their technique.

BAUHAUS school of architecture, craftsmanship and design founded at Weimar 1919 by Walter Gropius, moved to Dessau 1926, to Berlin 1932, closed down by the Nazis 1933; attempted to reconcile skilled design with modern industrial techniques and had widespread influence in Europe and America through the dispersal of its staff after 1933.

BLAUE REITER (Blue Rider) artistic movement formed in Munich 1911, held two exhibitions 1911, 1912, dispersed by war 1914; embracing many tendencies in modern art but fundamentally Expressionist, it included Kandinsky, Marc, Klee and Macke.

BRÜCKE (Bridge) artistic movement founded in

Dresden 1905, disbanded 1913; influenced by the Fauves but basically Expressionist, it included such artists as Kirchner, Schmidt-Rottluff and Bleyl and was additionally important for reviving the graphic arts, especially woodcuts.

COLLAGE picture created by sticking various materials, coloured and printed paper, fabric, string onto a canvas or board.

COMPOSITION arrangement of all the elements of a picture to create a pleasing or satisfactory whole.

CONSTRUCTIVISM abstract movement in sculpture and architecture founded in Russia *c.* 1917–20 by Naum Gabo and Antoine Pevsner.

CUBISM style of painting originated by Picasso and Braque which abandoned representation of one view of a subject and instead combined several superimposed views, often in cuboid or geometric form; first phase 1907–9, second (Analytical) 1909–11, third (Synthetic or Collage) 1911–16.

DADA (hobbyhorse) artistic movement, founded in Zürich 1915; violently anti-tradition, anti-art, anti-establishment, it aimed to outrage public opinion by emphasising the ludicrous.

DIVISIONISM (Neo-Impressionism) technique of painting whereby rather than being mixed on the palette, the pure colour is applied onto the canvas in small patches; these combine optically to produce a very rich and subtle effect. Seurat was the major exponent.

EXPRESSIONISM artistic movement of the late nineteenth and early twentieth centuries of which van Gogh was the forerunner and Edvard Munch the principal exponent; aimed at expressing the artist's inner emotions, using violent distortion, exaggeration, strong colour.

FAUVISM (fauve – wild beast) artistic movement including Matisse, Rouault, Dufy *c.* 1905–8, characterised by the use of violent colour, distortion and flat patterns.

FUTURISM Italian literary and artistic movement *c.* 1909–16 in which Balla, Boccioni and Severini were prominent; advocated break with artistic past and sought to integrate art into what they considered the glorious modern world of speed, violence and war.

IMPRESSIONISM artistic movement at its peak *c.* 1870–80, loose association of artists such as Monet, Renoir, Sisley, Pissarro who exhibited together; aimed to give an impression of a scene rather than reproduce it factually, to capture atmosphere, particularly out of doors and of landscapes; great emphasis on play of light, lack of firm outline, use of clear colour applied in small dabs.

JUGENDSTIL German term for Art Nouveau.

KINETIC ART 'moving' art based on theory that light and moving objects create a work of art; at its simplest a mobile; in more complex works involves motors.

NEO-PLASTICISM style of art developed by Piet Mondrian; was restricted to geometrical shapes set at right angles to the horizontal or vertical and to the three primary colours.

PALETTE board on which painter mixes his colours and hence the range of colours used by any one painter.

PERSPECTIVE technique for representing three-dimensional, i.e. solid, reality on a two-dimensional, i.e. flat, surface, based on the observation that objects at a distance appear smaller than those close to the spectator.

PICTURE PLANE the point immediately behind the frame of the picture at which the world of the observer and of the picture meet.

POP ART treatment of objects of everyday life, products of mass culture – advertisements, photographs, beer cans etc. as art forms in themselves and their use in works of art.

POST-IMPRESSIONISTS term used of Manet, Cézanne, Gauguin, van Gogh, Seurat, Matisse, Rouault, Picasso when exhibiting in London 1910 to describe their reaction to Impressionism.

POST-PAINTERLY ABSTRACTION artistic movement of 1960s, reacting against Abstract

Expressionism to produce large, cool, impersonal compositions of orderly colour.

PRIMITIVES term applied to either (a) art of non-European cultures, particularly of Africa and the Pacific and (b) unsophisticated artists, frequently self-taught, and whose technique is crude and naïve.

RAYONISM artistic movement founded in Russia 1911–12 by Mikhail Larionov and Natalia Goncharova; by the use of intersecting and parallel rays of colour, a picture should seem to float in time and space.

SECESSION withdrawal of groups of artists in Austria and Germany from academic institutions and exhibiting bodies to set up 'modern' movements.

SOCIAL REALISM realistic painting of the contemporary scene, often of the most deprived sectors of society

DE STIJL Dutch art periodical 1917–28 which promoted Piet Mondrian and Neo-Plasticism; name also given to group of artists associated with periodical.

STILL LIFE painting of objects, frequently flowers, fruit, books.

SUPREMATISTS movement founded by Malevich 1913 based on use of simple geometrical shapes in search of 'pure' art, free from any emotion or association.

SURREALISM movement including Magritte, Dali, Masson, Ernst, founded by André Breton 1924; aimed at the liberation of the imagination and of the unconscious mind, the freedom of the artist from rationality, it reconstructed the dream world and produced works of pure fantasy, hallucination and the grotesque.

VIENNA SECESSION secession led by Gustav Klimt, 1898.

WOODCUT relief printing technique in which the design to be printed is drawn on the surface of a block of wood, the part to be white is cut away, the surface inked and the block then pressed on paper to effect the printing.

Further reading

GENERAL HISTORY OF ART

Gombrich, E. H. *The Story of Art*, Phaidon, 1978
Janson, H. W. *History of Art*, Prentice-Hall & Abrams, 1974

TWENTIETH CENTURY ART

Arnason, H. H. *History of Modern Art*, Thames & Hudson, 1977
Banham, R. *Theory and Design in the Machine Age*, Architectural Press, 1960
Herbert, R. L. ed., *Modern Artists on Art*, Spectrum, 1965
Pevsner, N. *The Sources of Modern Architecture and Design*, Thames & Hudson, 1968
Read, H. *A Concise History of Modern Painting*, Thames & Hudson, 1975
Read, H. *A Concise History of Modern Sculpture*, Thames & Hudson, 1964

THE MOVEMENTS

Pre-twentieth century

Lucie-Smith, E. *Symbolist Art*, Thames & Hudson, 1972
Pool, P. *Impressionism*, Thames & Hudson, 1967
Rewald, J. *The History of Impressionism*, Secker & Warburg, 1973

Early twentieth century

Gray, C. *The Russian Experiment in Art, 1863–1922*, Thames & Hudson, 1969
Nash, J. M. *Cubism, Futurism, Constructivism*, Thames & Hudson, 1974
Vergo, P. *Art in Vienna 1898–1918*, Phaidon, 1975
Hodin, J. P. *Edvard Munch*, Thames & Hudson, 1972

Between the wars

Richter, H. *Dada*, Thames & Hudson, 1965
Wilson, S. *Surrealist Painting*, Phaidon, 1975

Post World War II

Lucie-Smith, E. *Movements in Art Since 1945*, Thames & Hudson, 1969
Wilson, S. *Pop Art*, Thames & Hudson, 1974
Wolfe, T. *The Painted Word*, Bantam, 1978